IMAGES
of America

AKRON WOMEN

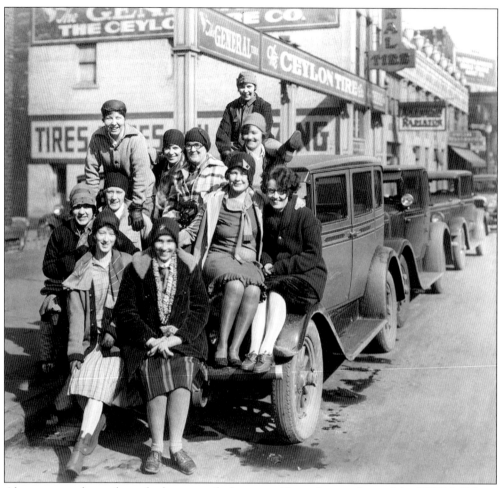

Akron women have always had a sense of adventure. Here, the members of the YWCA Hiking Club pile onto a car parked outside the Young Women's Christian Association (YWCA) headquarters on South High Street in the 1920s. Note all the tire signs. At this time, Akron was the home of many rubber and tire manufacturers. (Photograph courtesy YWCA of Summit County Collection.)

IMAGES
of America

AKRON WOMEN

Kathleen L. Endres, Carolyn H. Herman, and Penny L. Fox

ARCADIA

Published by Arcadia Publishing
Charleston SC, Chicago IL, Portsmouth NH, San Francisco CA

Printed in Great Britain

Library of Congress Catalog Card Number: 2004115817

For all general information contact Arcadia Publishing at:
Telephone 843-853-2070
Fax 843-853-0044
E-mail sales@arcadiapublishing.com
For customer service and orders:
Toll-Free 1-888-313-2665

Visit us on the internet at http://www.arcadiapublishing.com

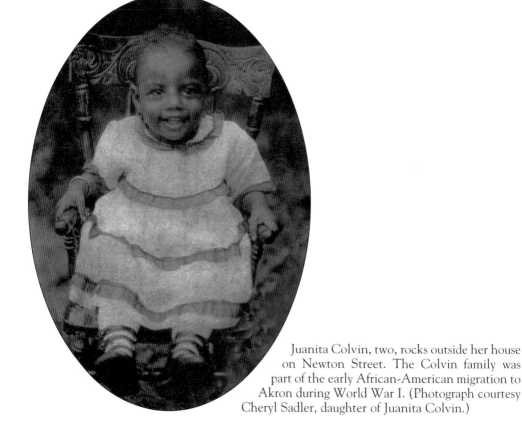

Juanita Colvin, two, rocks outside her house on Newton Street. The Colvin family was part of the early African-American migration to Akron during World War I. (Photograph courtesy Cheryl Sadler, daughter of Juanita Colvin.)

CONTENTS

ACKNOWLEDGMENTS

This book would not be possible without the assistance of many individuals. The authors would like to thank the many families who shared their stories and entrusted us with their precious photographs. Each family is acknowledged in the captions that accompany their photographs.

In addition, the authors would like to say a special thanks to several individuals who were especially helpful in the preparation of this work. First, Senior Archives Associate Stephen H. Paschen at the University of Akron assisted in so many different ways, suggesting archival collections that included wonderful photographs of women and then scanning to the specifications that the publisher required. Second, Director of Special Collections Judy James at the Akron-Summit County Public Library opened that institution's fascinating photographic collections to the authors and then scanned the photographs needed. The authors especially appreciated her suggestions, enthusiasm, and encouragement at deadline time. Third, retired Bibliographer Ruth Clinefelter from the University of Akron offered historical, personal, and political advice during the course of this project. Finally, the authors would like to thank the staff of Arcadia Publishing, Acquisitions Editor Melissa Basilone, Midwest Publisher John Pearson, and the technical support staff for making this book possible.

The authors would also like to thank our families, one trusty HP scanner, and a Mac G5.

INTRODUCTION

Conventional histories of Akron have focused on the founding fathers, the industrialists who built the giant rubber factories, cereal mills, and potteries, and the men who led the city and its institutions. In these narratives, women are missing or relegated to a footnote.

Nonetheless, Akron owes much to the women who braved the mud, filth, disease, and lawlessness of the canal days; who coped with a series of devastating panics, depressions, and reversals that left the city reeling in the 19th and 20th centuries; who worked hard at home taking care of their families; who labored in factories, department stores, and offices; and who formed clubs and organizations to help their churches and their community. Throughout the city's history, Akron women have woven the cultural and moral fabric of the city. They established churches, hospitals, schools, and cultural institutions.

But how do you tell the story that captures the rich diversity, determination, spirit, courage, and energy of this extraordinary population?

That became the overriding question as this book was conceived. The authors debated a variety of approaches—should it be a straight chronological account or stories of "great women" in Akron (typically women from households headed by affluent businessmen). The authors thought neither approach felt right. Instead, the authors decided to highlight the "ordinary" women who lived, loved, worked, and played in Akron.

This book is organized around a woman's life and provides a pictoral chronicle not normally covered in Akron histories. It illustrates the range of experiences in childhood: the daughter of an Italian immigrant rubber worker on North Hill enjoying a tea party with her favorite doll in the 1920s; an African-American girl hosting a birthday party for friends and relatives in the 1950s; Girl Scouts enjoying a trip on the Goodyear blimp in the 1930s; and a Soap Box Derby champion in the 1990s. The book also captures women as they come of age in Akron—hiking, skating, dating, or just plain fooling around.

Relationships emerged as a recurring theme in an Akron woman's life. Nonetheless, there is much diversity within those relationships. This book highlights that variety by showing wedding pictures of native Akronites and immigrants. Photographs tell the stories of marriages that failed and others that lasted a lifetime.

Family life in Akron is as varied. Photographs chronicle single, working mothers who struggled to bring up their children at a time when America only saw two-parent households. Other pictures show multi-generational, non-traditional, and blended families, families at work, families at play, families enjoying each other's company.

In this book, "work" has been redefined to include the many jobs that Akron women have held throughout history. Photographs capture women caring for their households and working as unpaid employees in family-run businesses. Pictures show women laboring in sweltering rubber shops, patiently working with children in classrooms, walking picket lines, and reporting the news.

Still, Akron women were not done. Somehow, they also found the energy to organize women's clubs and organizations, volunteer to help others, and create the great religious, cultural, health, and welfare institutions of the city. Akron women were also ready to let their hair down and enjoy *everything* that the Akron area had to offer, from bowling leagues to basketball, from Summit Beach Park to Chippewa Lake, from fan dancers at a nightclub to shopping in East Akron.

Of course, the story of Akron women is not over. In a sense, this book has a role to play in that story. Proceeds from the sale of this book will benefit the Women's Endowment Fund of the Akron Community Foundation, which supports projects benefiting women and girls in Summit County, Ohio, and the Women's Depository at the University of Akron Archives, which serves as a central repository for photographs, letters, manuscripts, and diaries of and about women from the area.

The authors hope you enjoy this stroll through the lives of Akron women and that you will preserve the history of the women in your lives.

One

GROWING UP

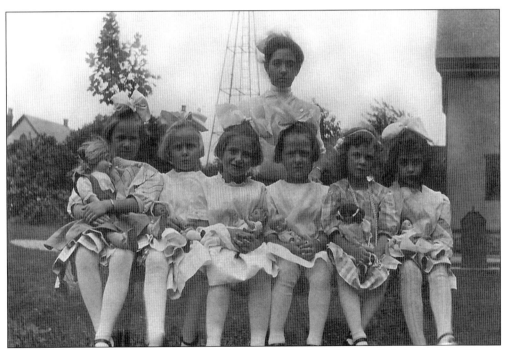

One spring day in the early 20th century, Margaret Elizabeth Gehres, left, invited her friends to a doll party. Each little girl brought her favorite doll for an afternoon of play at Margaret Elizabeth's house on South Highland Street. (Photograph courtesy June Roberts, Margaret Elizabeth's stepdaughter.)

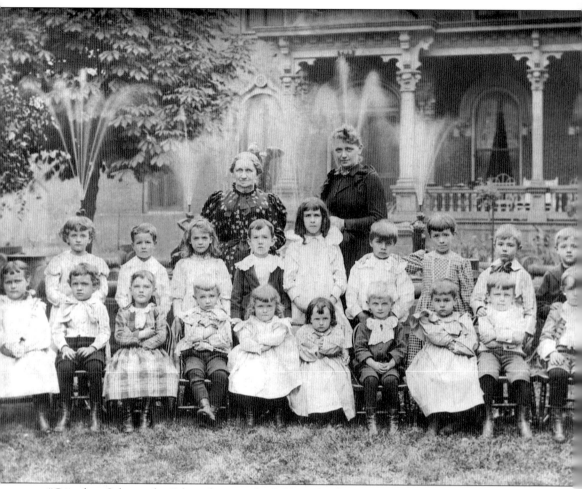

"Grandma Schumacher" (standing on the left), wife of cereal mogul Ferdinand Schumacher, ran a kindergarten in the family mansion on the corner of East Market and College Streets. The children came from the best families in the city. Those identified in this photograph are Mina Fuchs Kittlebuger, Earl Findlay, Blanche Sperry, George Sperry, Hazel Cole Burns, Sidney Smithers, Harvey Musser, Ethel Evans Hazard, Frederick Seiberling, Irene Seiberling, Edna Manbeck, William Habicht, Julia Pflueger, and Fred Fuchs. (Photograph courtesy Summit County Historical Society Collection.)

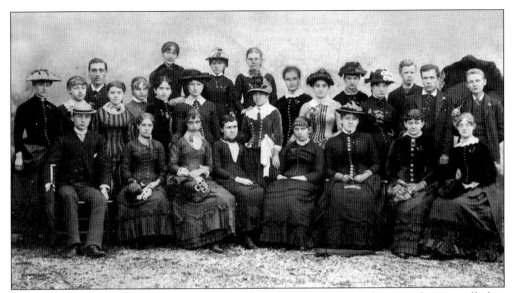

Akron opened its first public high school in 1886. This photograph shows students enrolled in that school in the late 19th century. In high school especially, more girls than boys attended, even though there were roughly equal numbers of each in the city. Boys dropped out to go to work. Those identified in this picture are as follows (left to right): (front row) Champ Belden, Ellen White, Frannie Austin, Anna Wilhelm, Cora Wise, and Nettie Stall; (second row) Clate Bowers, Emma Jones, Hattie Canfield, Jennie Weimer, Ella Downey, Sadie Motz, Hattie Seiberling, Carnie Allen, Mina Miller, Bertha Barnes, Helen Storer, Will Means, and Harry Chisnell; and (back row) Arthur Sacky, Alice Ingham, Sadie Gifford, and Sarah Russ. (Photograph courtesy Summit County Historical Society Collection.)

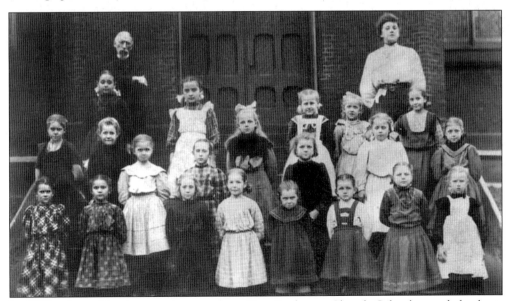

In 1907, when this photograph was taken, Zion Lutheran Church School served the large German immigrant community in the city. The girl's class poses with teacher Elizabeth Bense. The pastor of the church, the Reverend W. Lothman, also appears in the photograph. The girls are not identified. (Photograph courtesy Zion Lutheran Church.)

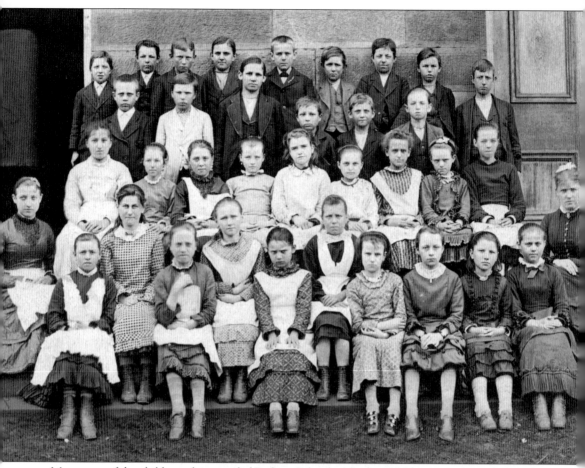

Meet some of the children who attended Perkins School in the late 19th century. According to the school board, Akron teachers—almost all of whom were women—were to be of "ripe age, ample experience, successful tact, a fine education, and an ample fund of general knowledge. Besides these, the teacher must have great goodness and kindness of heart, indomitable perseverance, good common sense, and last, but not least, the qualities, in a measure of a successful military general." (Photograph courtesy Summit County Historical Society Collection.)

Frances Hood remembered fondly her time as a Girl Scout in 1919. "We played basketball a lot with the scout group, and hiking was a big thing." Frances credited scouting with giving her "the ability...to get along with people. It taught me how to go out into the world and work with people and to help where help is needed." This photograph shows Frances' troop, although she is not identified. Troop leader Dorothy Alden is second from right. (Photograph courtesy Western Reserve Girl Scout Council.)

Scouting has been important in the lives of many girls from the Akron area. Girl Scout Troop No. 3, based at the Firestone Park Presbyterian Church, camps out at Camp Chanote in 1926. Neither the girls nor the leader is identified. (Photograph courtesy Western Reserve Girl Scout Council.)

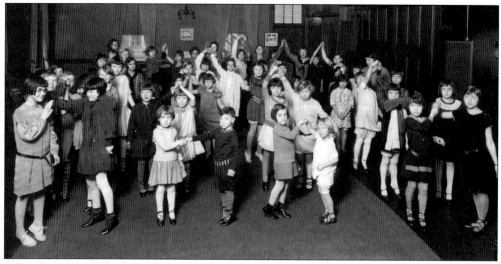

After the Young Women's Christian Association (YWCA) of Akron founded the International Institute as a branch of the organization in 1918, the group began offering classes that reflected a greater sensitivity and respect for immigrants and their cultures, like this one in folk dancing in 1929. (Photograph courtesy YWCA of Summit County Collection.)

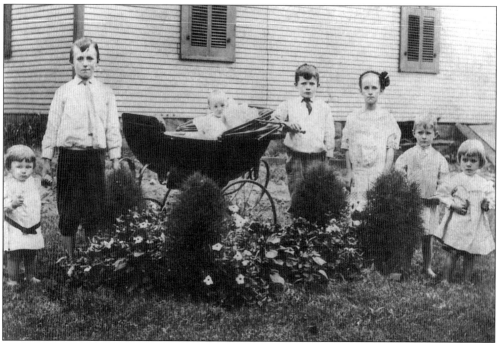

Like many Catholic immigrant families, the Reymann family grew to be quite large. Here, the children pose outside their Sherman Street house in "Goosetown" in 1911. The children are (from left) Marcel, Charles Jr. (Chick), Martin (in buggy), Joe, Helen, Gil, and Mary. In the years following, their parents, Charles and Salome Reymann, had nine more children. (Photograph courtesy Mary Ellen, Jean Ann, and Richard R. Reymann, grandchildren of Charles and Salome.)

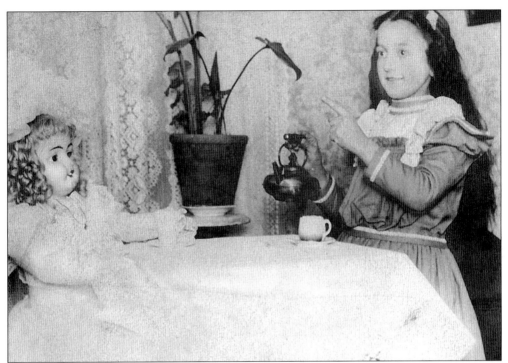

Mary Louise Giangrave entertains her doll with a tea party at her house on North Hill in the 1920s. Mary Lou was a life-long Akronite. (Photograph courtesy Kathleen L. Endres.)

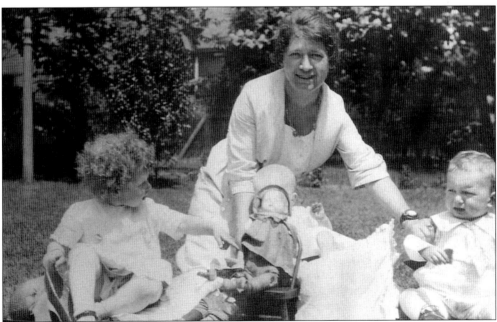

Ellen Casey, three, plays with her doll, her mother, and her baby brother outside her home in Goodyear Heights. Ellen's father worked at Goodyear Tire and Rubber Company. Her brother would grow up to be another Goodyear employee. (Photograph courtesy Kathleen L. Endres.)

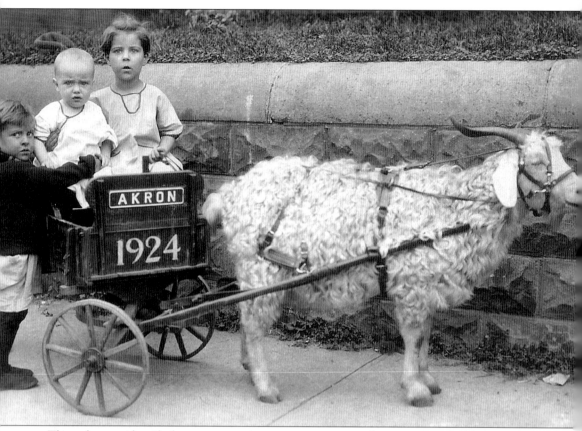

These three unidentified youngsters enjoy an outing in a goat-drawn carriage in Akron in 1924. (Photograph courtesy Kathleen L. Endres.)

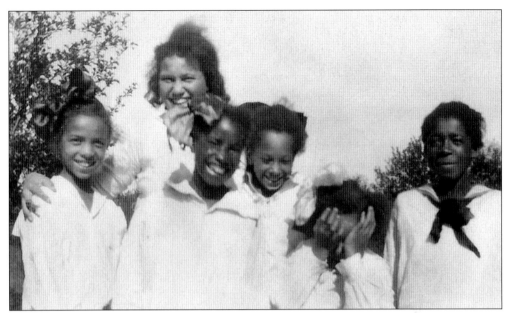

In Akron, Girl Scout troops were not integrated until well after World War II. The girls in this troop were not identified, but the photograph, of 1936, was probably taken at Camp Ledgewood. (Photograph courtesy Western Reserve Girl Scout Council.)

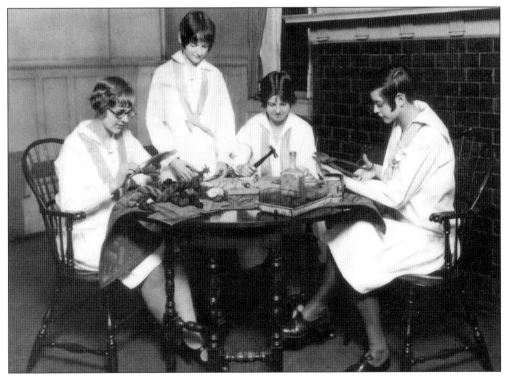

The Girl Reserves were the teen auxiliaries of the YWCA. These teens work on a craft project at the group's downtown headquarters on South High Street in 1929. (Photograph courtesy YWCA of Summit County Collection.)

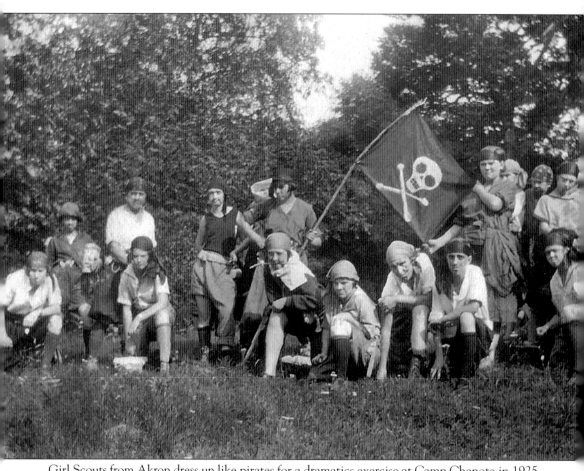

Girl Scouts from Akron dress up like pirates for a dramatics exercise at Camp Chanote in 1925. (Photograph courtesy Western Reserve Girl Scout Council.)

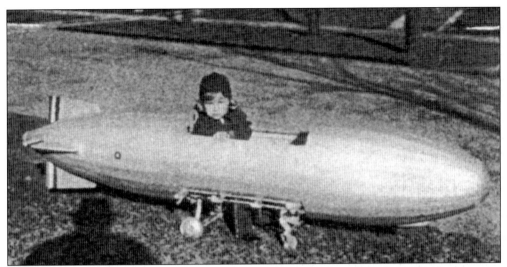

Almost every child in Akron secretly wanted her own Zeppelin, but Delores Jean Frasier, two, was lucky. Her grandfather John Scouler, an employee of Goodyear Tire and Rubber Company, built her one. Delores' airship was eight feet long and built so the little girl could drive it herself. The Zeppelin came complete with navigation lights and propellers. (Photograph courtesy *Wingfoot Clan*.)

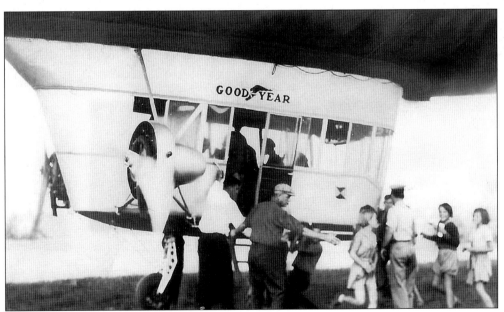

In 1932, the first year of Girl Scout Camp Ledgewood, C.W. Seiberling, co-founder of Goodyear Tire and Rubber Company and board member of the organization, arranged for all the campers to ride on the airship *Reliance*. Because the passenger car (the gondola) could carry only a few passengers, the blimp had to make at least 20 trips to accommodate all 123 girls. (Photograph courtesy Western Reserve Girl Scout Council.)

Lucrete Arrington (left) and her parents moved up to Akron from Georgia in the 1920s when job opportunities in the rubber factories seemed endless. Both Lucrete's mother and father worked in the rubber factories, as did Lucrete, briefly, after graduation from high school. (Photograph courtesy Fred Endres, son of Lucrete.)

The public schools of Akron were not fully integrated in the early days of the 20th century. Juanita Colvin, 10, was the only African-American girl at King School when this photograph was taken. (Photograph courtesy Cheryl Sadler.)

Dorothy Eileen Johnson, about 10, poses outside the neighborhood beauty parlor on College Street during World War II. (Photograph courtesy Dorothy Johnson's daughter, Dolli Quattrocchi Gold.)

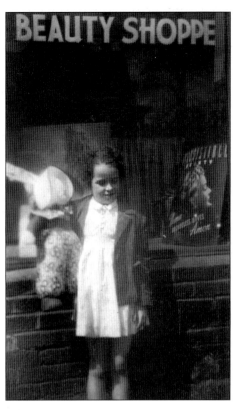

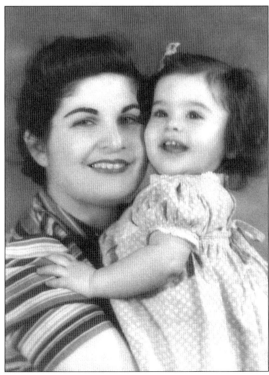

Ties were especially close between mothers and daughters. Lillian Cohen is pictured with daughter Arlene in the early 1940s. (Photograph courtesy Arlene Cohen Rossen, the little girl pictured.)

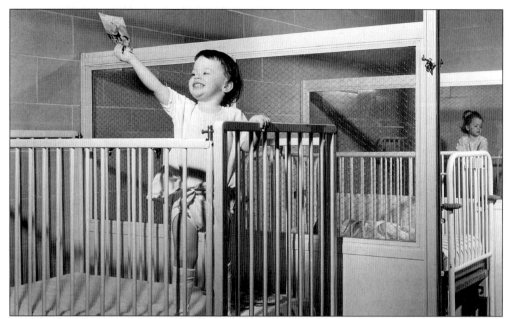

For many children, going to the hospital can be a scary experience, but not for Kathryn "Kitty" Kilroy. It was just like spending time at mom's work. Kitty's mom, Janice Dunn Kilroy, was in charge of Accounts Receivable for the emergency room at Children's Hospital. Here, Kitty, about two, flashes a smile after she had her tonsils removed in 1950. (Photograph courtesy Kathryn Boatwright, the former Kitty Kilroy.)

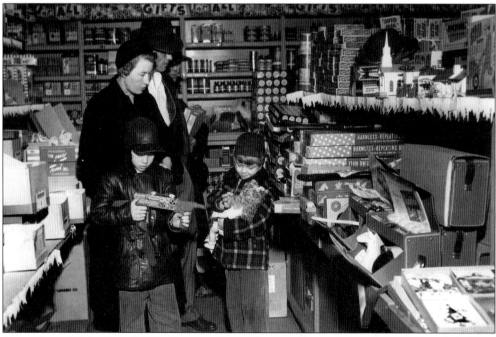

Ann, Mack, Michael, and Alice Boatwright go Christmas shopping at the B.F. Goodrich Store on Exchange Street in 1952. Only BFG employees could shop there. That Christmas, Michael chose a gun and Alice got a doll. (Photograph courtesy Kathryn Boatwright.)

22

In 1950, the girls of the scout troop from Grace Reformed Church were asked to provide mementos for a time capsule to be opened in 2000. The girls came up with predictions and personal notes. The girls from that troop are as follows: (from left, along with their predictions and personal notes) Sally Abernathy ("adventurous, fun-loving"), Lavada Park (no personal note), Imojean Gillentine ("missionary religious work"), Mildred McLeod ("wants to be 'old maid'"), Alice Albrecht ("baseball player"), Yvonne Ellis ("mother of large family"), and Norma Fiscus ("quiet, serious and a good mother"). (Photograph courtesy Western Reserve Girl Scout Council.)

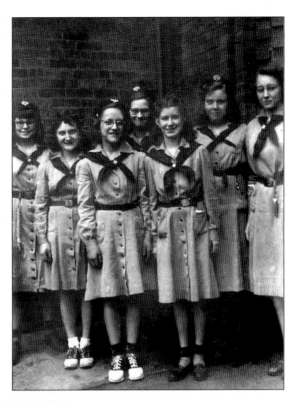

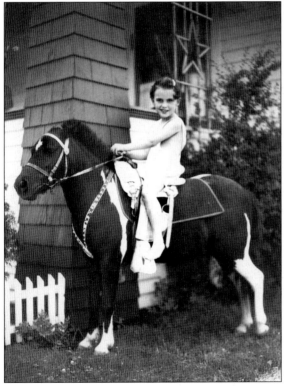

Many children wanted a pony, but zoning regulations in Akron prevented it in most neighborhoods. Nonetheless, some children, like Mary McGill, only four when pictured here in 1947, were able to ride one, courtesy of a pony-for-hire brought around the neighborhood by an enterprising photographer. (Photograph courtesy Mary Boley, pictured on the pony.)

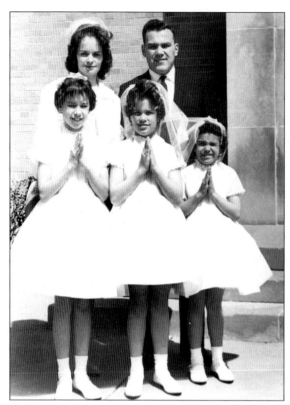

Receiving First Communion is a time of celebration for a young Catholic. Here, the three Quattrocchi sisters, (from left) Dolli, Kathy, and Tina, pose with their parents, Dorothy Eileen and John, outside St. Peter's Church on Russell Avenue. (Photograph courtesy Dolli Quattrocchi Gold.)

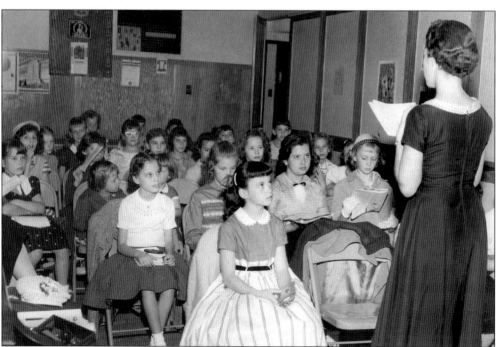

The girls of Grace United Brethren Church in South Akron gather for Sunday school class in 1957. (Photograph courtesy Kathryn Boatwright, the former Kitty Kilroy, seated in the front row.)

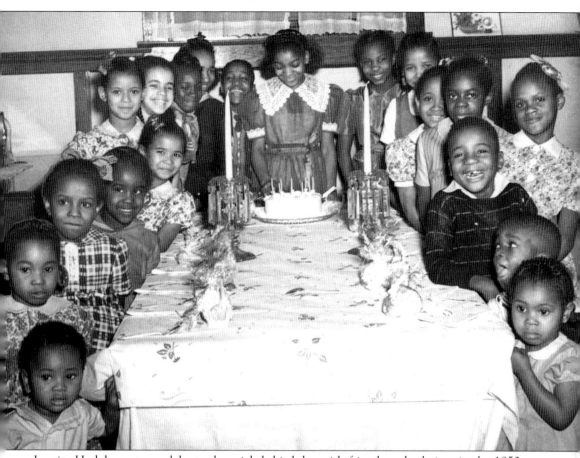

Juanita Hodok, center, celebrates her eighth birthday with friends and relatives in the 1950s. (Photograph courtesy Sam Shepard Collection.)

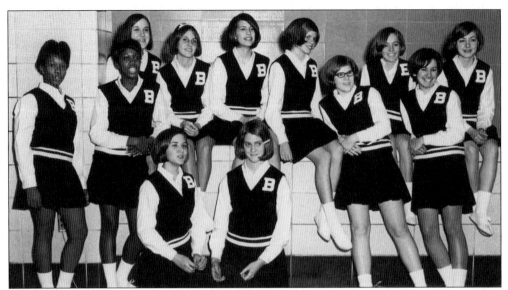

In the 1960s, many high school girls aspired to be part of the cheerleading squad. Here, the 1968–1969 Buchtel High School Junior Varsity Cheerleading squad poses. They are (kneeling, from left) Barb Spangler and Annette McElhinny; (standing, from left) Sylvette Long, Vicki Poole, Kathy Hanahan, and Dolli Quattrocchi; and (sitting, from left) Mary Jo Androsky, Nancy Velimirovich, Judy Harrison, Davette Williamson, Barb Fosbrink, and Jane McDermott. (Photograph courtesy Dolli Quattrochi Gold, one of the cheerleaders.)

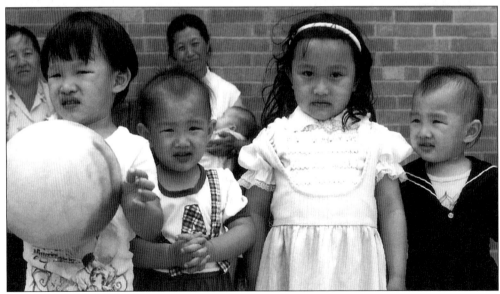

Over Akron's long history, immigration has been a constant. The nationalities, races, and religions may have changed, but the common problems faced by immigrant groups, such as adjusting to a new way of life, have remained the same. Here, Hmong and Laotian children enjoy a picnic at Goodyear Park. (Photograph courtesy International Institute.)

There was a time when you would not see girls competing at the Soap Box Derby. Back in 1935, when the Derby moved to Akron, only boys were allowed to race. In 1970, girls won the right to compete, and five years later, Karren Stead became the first girl to win the race. These days, girls represent more than 45 percent of all those competing. Here, some Derby girl competitors enjoy some time together. (Photograph courtesy Soap Box Derby.)

Two unidentified children, daughters of immigrants to this country, enjoy a day of playing at one of the city's parks. (Photograph courtesy International Institute.)

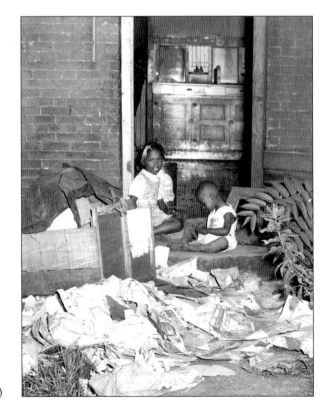

Children in Akron did not always grow up in ideal conditions. This little girl and her brother grew up in one of the poorer sections of town in the 1950s. (Photograph courtesy Sam Shepard Collection.)

Two

COMING OF AGE

Mabel, who lived at 670 Sherman Street in South Akron, sent this postcard home to a friend in West Union, Ohio, in 1916. Like many young women, Mabel moved to the city to find work, and she liked what she found. "I am working every day and like Akron fine," she wrote. (Postcard courtesy Kathleen L. Endres.)

The story behind this photograph was lost decades ago. Suffice it to say, this fashion-conscious miss enjoyed her time in Akron. (Photograph courtesy Kathleen L. Endres.)

Akron beckoned many girls from small towns and farms for a day or a weekend of "big city" fun. Lena Krakow, for example, took the train to Akron with her sister Mary. This photograph was probably taken that day. Lena lived with her family in Ravenna, the Portage County seat. She and her family were born in Bavaria. In 1880, about the time this photograph was taken, she worked in a store in Ravenna. (Photograph courtesy Kathleen L. Endres.)

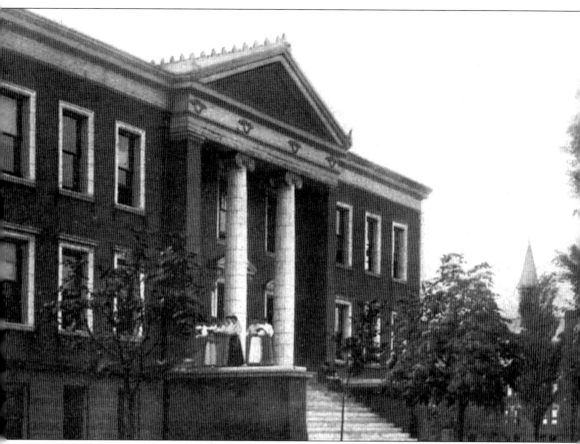

Established by the Ohio Universalist Convention in 1870, Buchtel College (now the University of Akron) admitted women from its start. Women also held administrative and faculty positions early in the college's history. Many women of Buchtel College—students, graduates, administrators, and faculty wives—also became community leaders in the city, establishing one of the early women's councils in the nation and pushing hard for suffrage. In this postcard, female students pose outside the main building on campus, Buchtel Hall. (Postcard courtesy Ruth Clinefelter.)

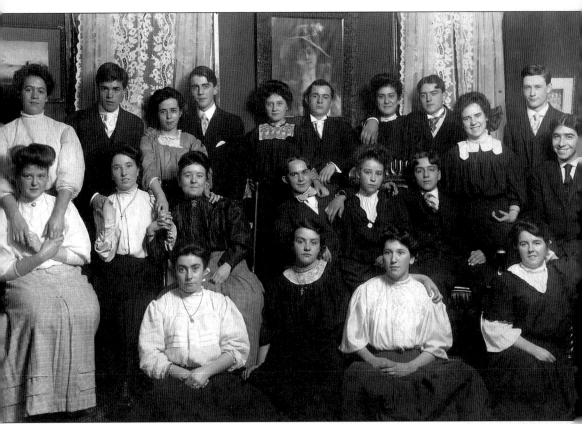

Welcome to the home of Jessie Heffernan, 70 North Walnut Street. On November 22, 1906, Jessie invited a few friends over for a party, and here they pose for the photographer. (Photograph courtesy Kathleen L. Endres.)

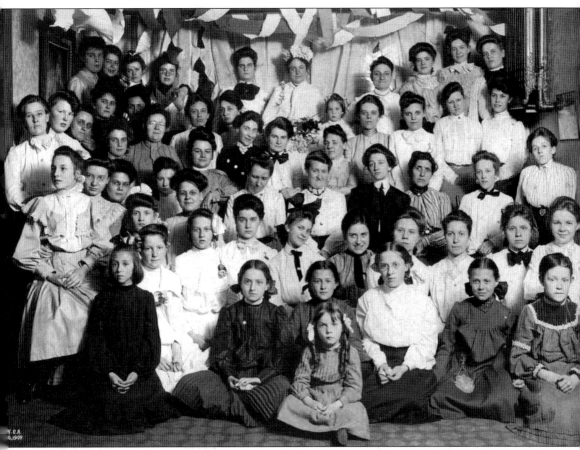

This photograph is one of the earliest photographs of members of the YWCA in Akron. Taken in 1904, just three years after the YWCA was founded in Akron, the photograph shows the cross-section of women drawn to the organization. (Photograph courtesy YWCA of Summit County Collection.)

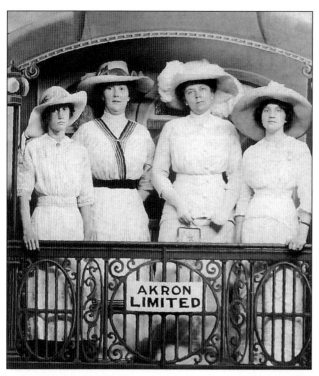

Four young unidentified women pose in the popular "Akron Limited" railroad prop at an Akron photographer's studio. (Photograph courtesy Kathleen L. Endres.)

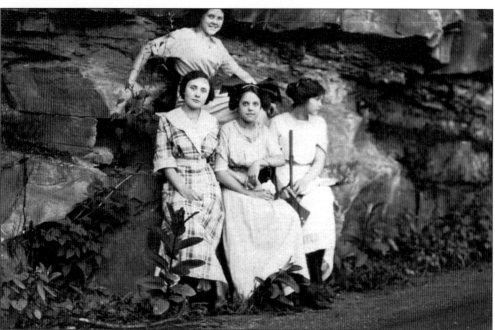

Helen Erdman-Hinderman (in the plaid dress) enjoys a day out with the Krohn sisters, Joan, Mary, and Ruth. Helen wrote on the photograph, "They are the dandiest girls I have met since I have been here." Helen was born in Akron, but her family moved frequently. She eventually returned to Akron before World War I. (Photograph courtesy Denise Remark Lundell, Helen's granddaughter.)

Hillie, Nancy, and Elizabeth Frantz wait for the train to take them to Akron, and teaching jobs there, in 1915. Akron schools had a burgeoning enrollment at the time and always needed teachers. The three got teaching jobs at Lane School and roomed together. (Photograph courtesy Gail James.)

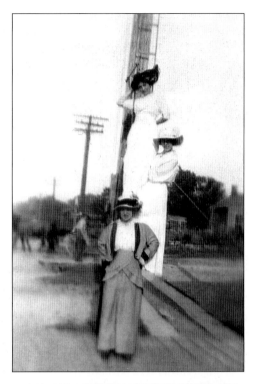

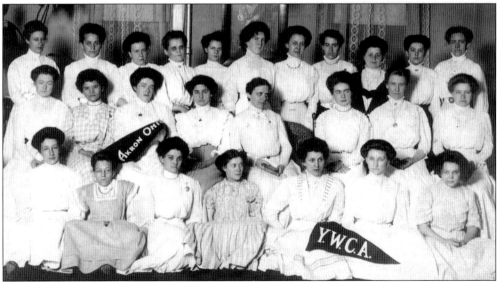

Meet the ABO secret society. Only members of this YWCA Bible class knew what the ABO stood for. They are as follows (from left): (top row) YWCA General Secretary Sarah Lyons, Florence Beal, Mildred McAfee, Stella Black, Minnie Rorick, Alice Small, Celia Beeler, Grace Potter, Elizabeth Smith, Nellie Rake, and Della Denious; (middle row) Emma Tschantz, Anna Kiehl, Nana Carrell, Olive Schnee, instructor Carrie Eggers, president of the class Elsie Prear, Janet Adamson, and Jennie Bridwell; and (front row) Rose Zeller, Elizabeth Hanni, Sophia Kiehl, Marion Carrell, Minnie Spidel, Carrie Geib, and Cora Rorick. (Photograph courtesy YWCA of Summit County Collection.)

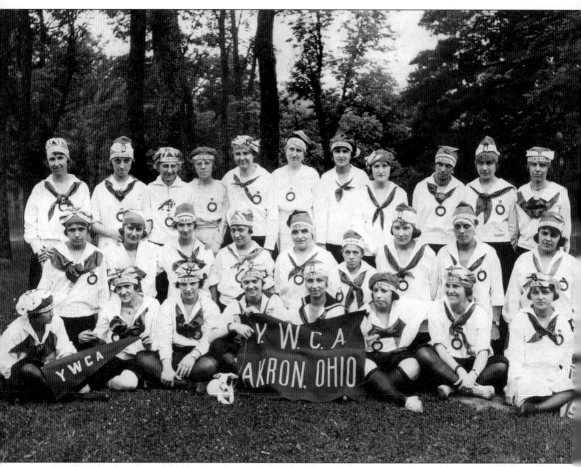

The "Miller Bathing Caps" pose at a YWCA-sponsored summer camp during the 1920s. These women worked at Miller Rubber Company. By World War I, almost every rubber shop in the city had some connection with the YWCA and many factory women enjoyed a week away at the organization's summer camp. (Photograph courtesy YWCA of Summit County Collection.)

Vida Merle Christopher came to Akron from Pisgah, West Virginia, in 1920. She wanted a good-paying job in a rubber factory and a little freedom from her small town and her big family—her parents had 15 children. She found all of that in Akron during the 1920s. Vida worked in the cafeteria at Goodyear Tire and Rubber Company and enjoyed some good times in the city. Here, she is pictured with friends: Mary Shank (at left), an unidentified woman (at center), and Vida stands at right. (Photograph courtesy Mary Boley, Vida's daughter.)

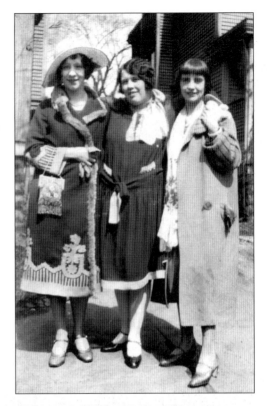

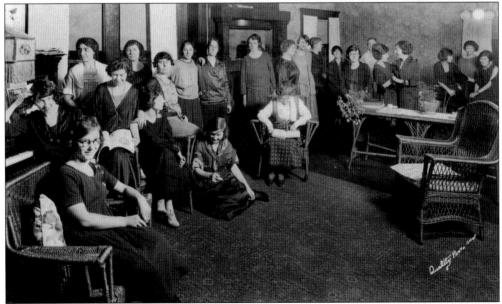

Women who came to Akron to find work were often hard pressed to find clean, safe, affordable housing. The Akron YWCA made reasonably priced housing for working women one of its top priorities. In 1920, the YWCA opened the "Blue Triangle" dormitory on South Union Street. This photograph shows the living room where the YWCA-dormitory residents enjoyed a wholesome, family-like environment. (Photograph courtesy YWCA of Summit County Collection.)

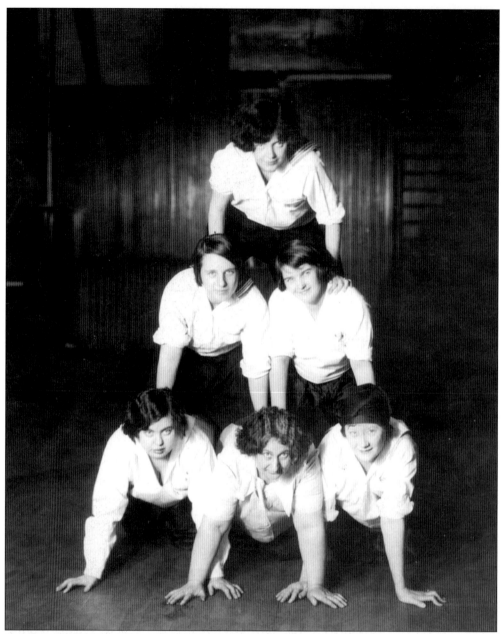

In 1906, the YWCA received a gift that made all the difference in the world to Akron women. That year, the Union Charity Association donated Grace House, on South High Street, to the organization. The Akron *Times Press* marveled at the renovated building when the YWCA moved in. The building is "beautiful, cozy and a refuge to the tired and weary, and a place where counsel and comfort can always be had merely for the asking." It also meant state-of-the-art gymnastics facilities. Here, six members of the YWCA use the Grace House gym. (Photograph courtesy YWCA of Summit County Collection.)

These four friends, (from left) Bernice, Anne Gilblom, Rena McCabe, and Jean Gilblom, pose after their lifesaving class in 1928. Anne Gilblom, a standout athlete in swimming and basketball, was offered a scholarship to Northwestern in 1932, but she could not afford to take it. Instead, she married Martin Reymann and had 10 children. Anne Gilblom Reymann died at the age of 37 in 1950. (Photograph courtesy Mary Ellen, Jean Ann, and Richard R. Reymann, and Phyllis Reymann Bruno, the children of Anne and Martin Reymann.)

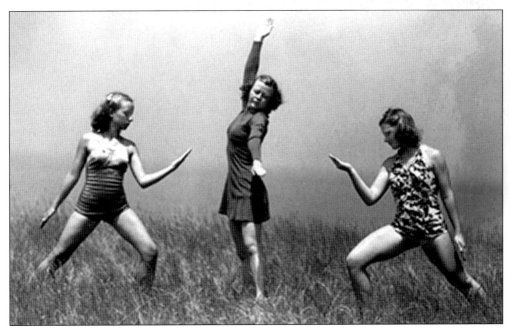

Camp YaWaCa was an outdoor paradise on Lake Erie for Akron girls. Run by the YWCA in the city, the organization sent many "industrial girls," women who worked in the factories, for a week in the country. Most of the girls who went to the camp, however, were members of the Girl Reserves or Y-Teens, both teen auxiliaries of the YWCA. (Photograph courtesy YWCA of Summit County Collection.)

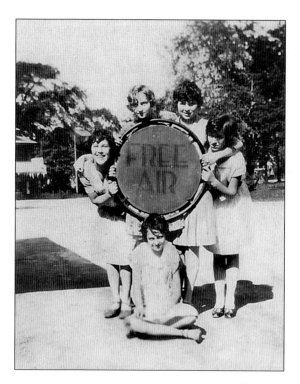

Five friends show their sense of humor when they pose around the "free air" sign at an Akron gas station. (Photograph courtesy Jean Reymann.)

For women, employment at a rubber factory meant much more than working eight hours a day. Rubber companies set up athletic teams, physical fitness programs, and self-improvement classes for women and men. Here, an unidentified Goodyear employee shoots some hoops in 1920. (Photograph courtesy Goodyear Tire and Rubber Company Collection.)

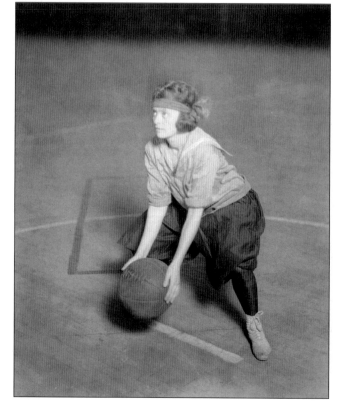

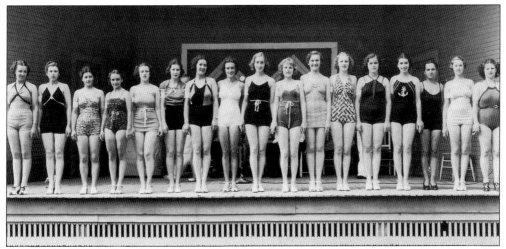

In 1936, General Tire and Rubber Company sponsored a beauty pageant for the single women who worked for the company and relatives of employees. Here, the contestants line up for the swimsuit competition. The winner that year turned out to be married, and that caused quite a stir company-wide. (Photograph courtesy Donna Dowler, daughter of the contestant, fourth from right.)

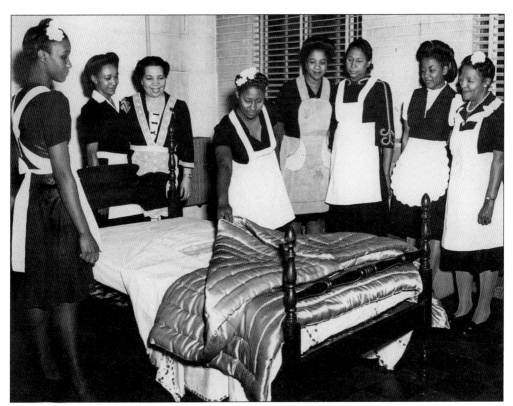

This homemaking class was held in the Akron Community Center in 1945/1946. (Photograph courtesy Sam Shepard Collection.)

The "roving photographer," who snapped candid photographs of pretty women as they shopped downtown, captured Sally Rotilie, 16. Sally, a junior at North High School in 1937 when this picture was taken, was strolling down Main Street in search of a bargain. (Photograph courtesy Donna Dowler, Sally's daughter.)

Iva Garlitz, 16, and Gladys Frantz, 19, pose behind the old YWCA building on South High Street. The two met when they first moved to Akron. Both worked in the restaurant in the YWCA, and Iva lived at the "Y." Gladys remained in the city and worked at Firestone Tire and Rubber Company for a time and then the Akron Credit Bureau. She lived to be 100 years old. (Photograph courtesy Kathryn Boatwright, Gladys' granddaughter.)

During World War II, Akron was a swinging town with lots of places to entertain a young woman. Mertus Swain had this photograph taken at the Cosmopolitan Club on South Howard Street. (Photograph courtesy Cheryl Sadler.)

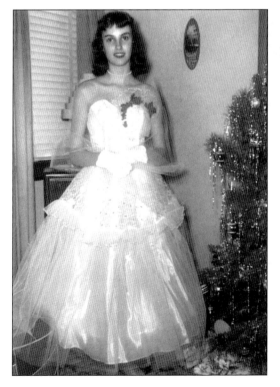

In Akron in the 1950s, dating was a little different. Here, Mary McGill poses beside her family's Christmas tree before leaving on her very first date in 1957. Mary, only 14, was off to the Rainbow Girls' Christmas formal with "Junior" Coleman. (Photograph courtesy Mary Boley, the former Mary McGill, who remembers her first date fondly.)

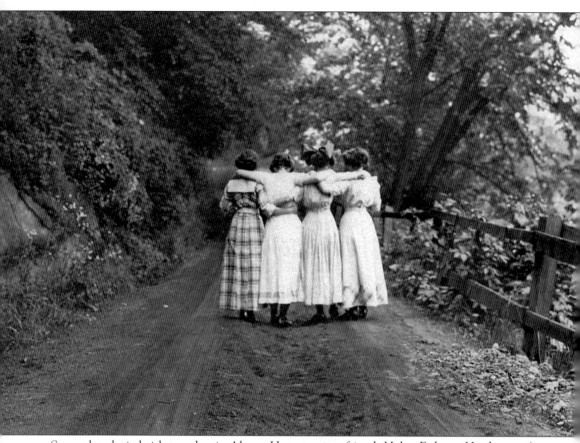

Strong bonds tied girls together in Akron. Here, teenage friends Helen Erdman-Hinderman (in plaid dress), Joan Krohn, Mary Krohn, and Ruth Krohn enjoy a walk along a quiet road in Akron. (Photograph courtesy Denise Remark Lundell.)

Three

LOVE AND MARRIAGE

Frank Endres and Margaret
Lucrete Arrington were high
school sweethearts, so no one was
surprised when the two married
in 1941. The first few years of the
marriage were difficult because
Frank enlisted in the Navy and
the two were separated. After his
return from war, the couple
settled down in Akron, built a
house in Goodyear Heights, and
ran the Bon-Ton Bakery on
Lover's Lane. Today, the couple
lives in that same house.
(Photograph courtesy Fred
Endres, their son.)

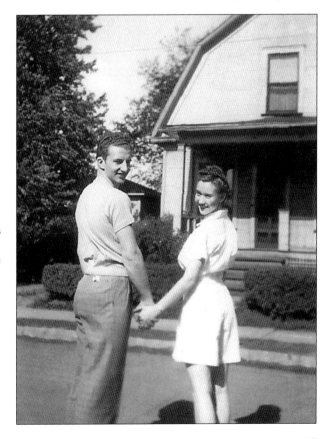

Meet Veronica Moehr. Veronica and her husband Henry lived at 108 Silver in the 1890s. He worked in the Twine Works; no occupation was noted for her. (Photograph courtesy Kathleen L. Endres.)

George Ody and Louise Spade met and married in Akron. This photograph was taken on their wedding day, May 11, 1907. George was a potter, and Louise was the daughter of a potter who was the foreman at Robinson Clay Products in Middlebury. George and Louise lived on Kelly Avenue in a house Louise's father built. The couple had three daughters in Akron before buying a farm in Windham, Portage County, Ohio. The family lost the farm during the Great Depression, and the couple never bought another house or farm. (Photograph courtesy Donna Russell, granddaughter of George and Louise.)

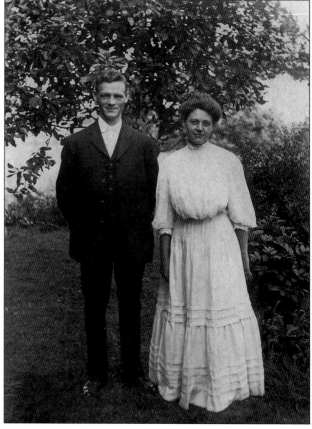

Charles Reymann and Salome Zaber, both immigrants from Alsace Lorraine, married in St. Bernard's Catholic Church on May 3, 1906. It was Salome's first marriage and Charles' second. His first wife had died, leaving him with three small children to rear. Salome became the nanny for those children. After they married, Salome and Charles had 12 children of their own. (Photograph courtesy Mary Ellen, Jean Ann, and Richard R. Reymann, grandchildren of Charles and Salome.)

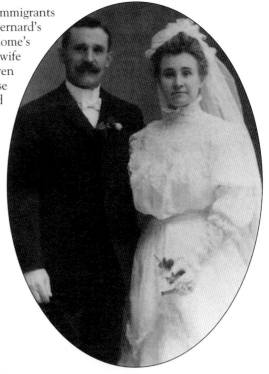

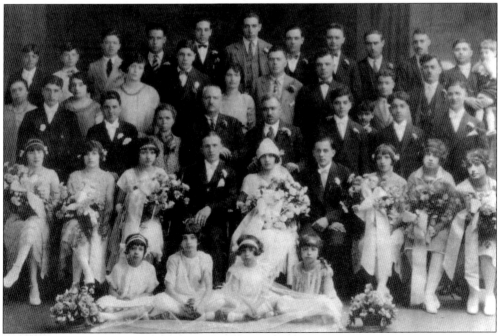

In the Italian immigrant community, weddings were a time of great celebration for the families. Here, in the 1920s, Lewis George and Anna Scifido pose for their wedding picture with members of the wedding party and relatives. (Photograph courtesy Donna Dowler, the daughter of one of the flower girls.)

The Ohio Bell girls gave a wedding shower for one of their own, Marie Oser, who married Corwin Carter on June 30, 1931. The women are as follows (from left): (back row) Estella Kelly, Anna Burg, and Mary Geldebride; (middle row) Edna Wright, Mildred Barlett, and Ella Thornton; and (front row) Marcella Moxley. (Photograph courtesy Bev Coss Photograph Collection.)

Evelyn Hill and Joseph Donnelly married at the Arlington Street United Brethren Church in 1930. It had been a very special romance. Evelyn was a celebrity in Akron. She was the leader of the Ritzy Revelers dance orchestra and a dancer; during the day, she worked in the office of Goodyear Tire and Rubber Company, which is where she met her husband. Joseph was a messenger who delivered the mail on roller skates. He was forever showing off for Evelyn and asking her out on dates. She finally relented, if Joseph would buy a ticket to her dance recital. The two double dated after the recital and were inseparable for the next 65 years. Evelyn was 23, and Joseph was 19 when they married. Evelyn liked to say she married him young "so [she] could raise him right." (Photograph and story courtesy Donna Vinciguerra, Evelyn and Joseph's daughter.)

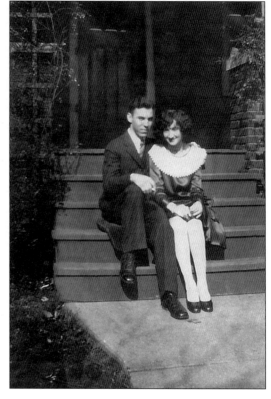

In 1932, Anne Gilblom, 19, married Martin Reymann, 22. They did not seem to have much in common. Anne was Jewish and the daughter of a rubber factory worker. Martin was a Catholic and the son of the owner of Atlantic Foundry. Anne converted to Catholicism and had 10 children before she died at the age of 37. (Photograph courtesy Jean Anne Reymann, daughter of Anne.)

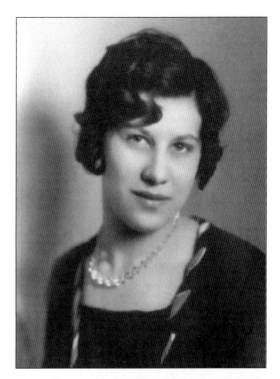

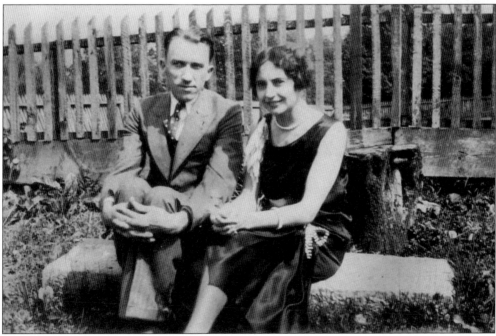

Vida Merle Christopher and Charles McGill had lots in common when they courted in Akron in the 1920s. Both were products of small towns in West Virginia. Vida was from Pisgah, and Charles was from Red House. They met at Goodyear Tire and Rubber Company, where they both worked. The two eventually married, in 1929, and had one child. (Photograph courtesy Mary Boley, daughter of Vida and Charles McGill.)

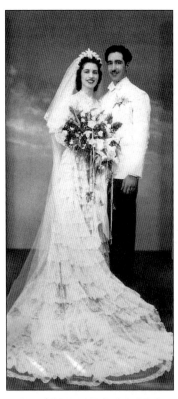

Strong, long-lasting marriages ran in the Procaccio family. Dominica Dicentio and Peter Procaccio (below) are shown on their wedding day in 1917 in Akron. The two were immigrants from Italy who settled in the city's Italian community on North Hill in the late 19th century. Like many Italian immigrants, Peter and Dominica tried to preserve the "Old World" ways, even refusing to speak English in their home. Both, however, understood the language. Presumably, Peter did speak English at work at the B.F. Goodrich factory. The newlyweds are pictured with Charles and Lucy Rich, who witnessed the ceremony at St. Martha's Catholic Church in North Hill. Their son Louis (pictured left on his wedding day in 1940) was as fortunate. He married Santana "Sally" Rotilie at St. Martha's. The two had much in common. Both were products of Italian parents and attended North High School. Louis was a carpet layer for O'Neil's Department Store downtown. The couple had four children: Donna, Peter, John, and Angela. Because Sally remembered how teachers made fun of the Irish and Italian children in school, she insisted that her children not display ethnic characteristics and so brought them up to be "very American." When Angela, the youngest, was in seventh grade, Sally got a job at Montgomery Ward and worked there until her retirement. (Photographs courtesy Donna Dowler, daughter of Sally and Louis and granddaughter of Dominica and Peter.)

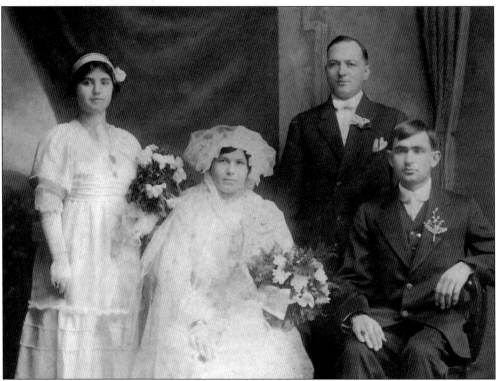

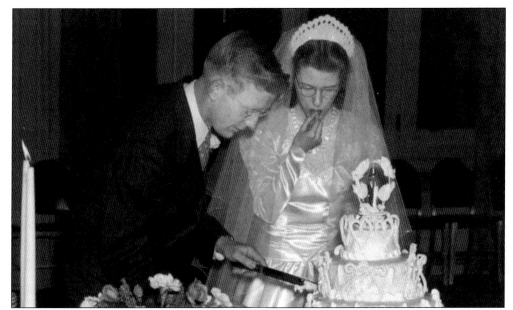

Lillian Marie Baxter and Fayne Stuart Chopard met at an ice cream social at High Street Christian Church in Akron. They married at that church in 1945, after Fayne was discharged from the Army. Lillian was just 19, and Fayne was 22. After their marriage, the couple moved to Cuyahoga Falls, a community near Akron, and had three children. (Photograph courtesy Marie Van Meter, Lillian's daughter.)

On June 22, 1942, June Hoffmeyer married William Henry Roberts in Akron. Eight years later, the couple divorced. June moved back to Akron with her two sons and started her life as a working mother. She never remarried. From left are Elaine Everett, Jean Krumroy, June Hoffmeyer Roberts, Carol Williams, Irene McMonigal, and Betty Hamlin. (Photograph courtesy June Roberts.)

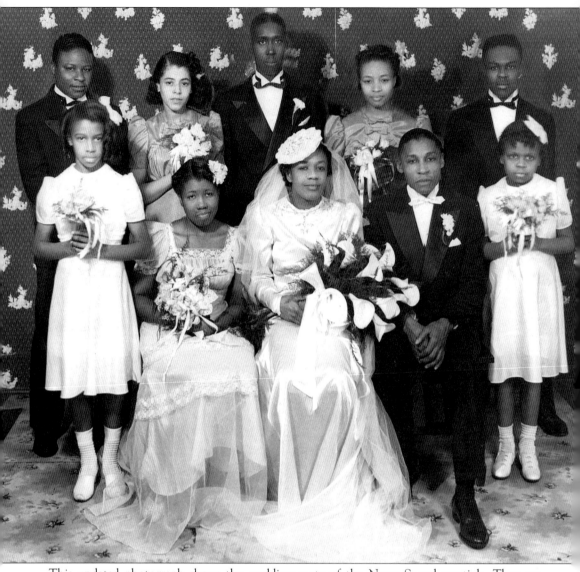

This undated photograph shows the wedding party of the Nurse-Sneed nuptials. They are identified as (standing, from left) Aron Sneed, Doris Callender, John Kirk, Bernice Robinson, and Charles Nurse; and (front row) Sylvia Nurse, Ruby Brown, Mrs. and Mr. Sneed, and Auris Rogers. (Photograph courtesy Sam Shepard Collection.)

Romance can last a lifetime. Luther and Marie Campbell were celebrating their 25th anniversary in their home at 608 Easter Avenue when this photograph was taken. Luther worked at the B.F. Goodrich Company. (Photograph courtesy Sam Shepard Collection.)

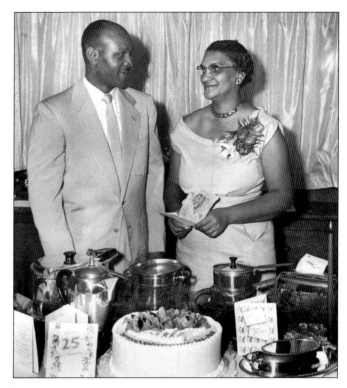

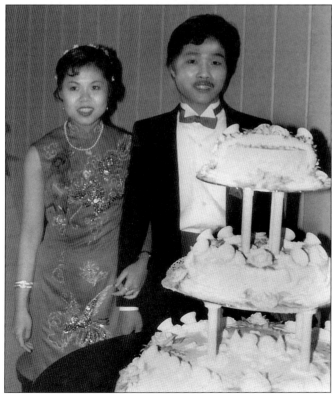

The Vinh Quan Lam-Lang Heng wedding made history in Akron in 1985. It was the first wedding ever held at the International Institute. (Photograph courtesy International Institute.)

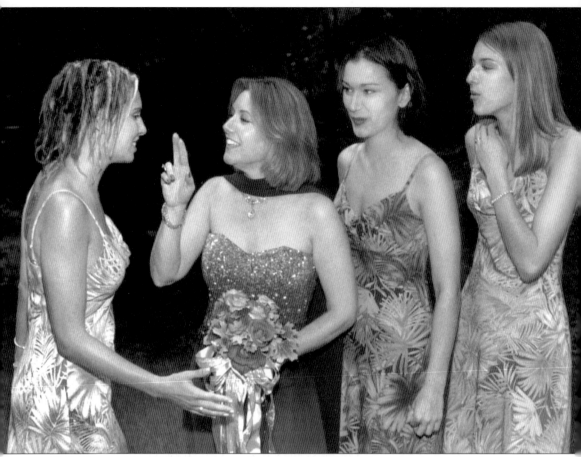

Dolli Quattrocchi Gold celebrates at her wedding with her three daughters from her previous marriage. They are pictured as follows (from left): Gayle Carter, Dolli, Meghan, and Elizabeth Markovich. (Photograph courtesy Dolli Quattrocchi Gold.)

Four
FAMILY LIFE

Esther Milkman Narotsky, center, was born in Lithuania. She came to America with her three children in 1902. Her husband, Samuel Milkman, had immigrated earlier, saved money, and sent for his family. The family moved to Akron around 1905, at a time of a great influx of Eastern Europeans into the city. In 1907, her husband and one child died. Shortly afterward, Esther opened a small grocery store on Sherbondy Hill so she could support her family. Her daughter, Rae Milkman Eichner (left) dropped out of school in the fourth grade so she could help in the store and take care of the younger children. Esther continued to run the store until she remarried. This photograph was taken on the wedding day of Esther's granddaughter, Lillian Eichner Cohen (right), in 1938. (Photograph courtesy Arlene Cohen Rossen, great granddaughter of Esther.)

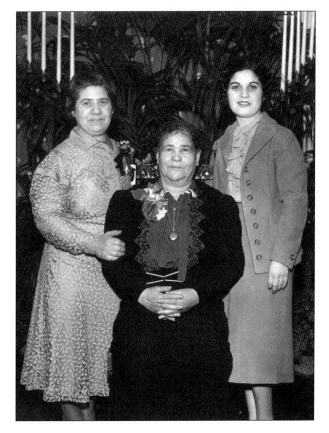

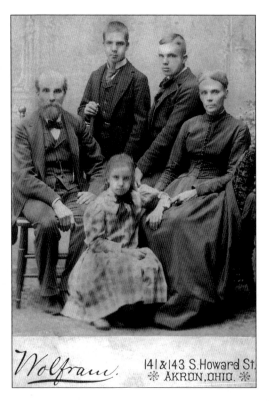

Wolfram. 141 & 143 S. Howard St.
✳ AKRON, OHIO. ✳

Meet the Dixon E. Shepard family in Akron, *circa* 1885. Dixon and Harriet (Hattie) Parker married in Cuyahoga County in 1864. By the time they moved to Akron in 1880, their family included Julius (right) and Roy. Daughter Bessie (front) was the baby of the family. At various times in his life in Akron, Dixon worked as a tinner, a bicycle dealer, and a locksmith. Harriet never worked outside the home. By 1901, Bessie was working as a telephone operator and continued to live with her parents. (Photograph courtesy Kathleen L. Endres.)

The Reverend W. Lothman poses in the upper window of Zion Lutheran Church's parsonage on November 26, 1879. His wife Betty holds baby Helen, while daughters Lydia, Emma, Ida, and Gertrude play outside. The Lothman family served the Zion Lutheran Church community for more than 50 years. (Photograph courtesy Zion Lutheran Church.)

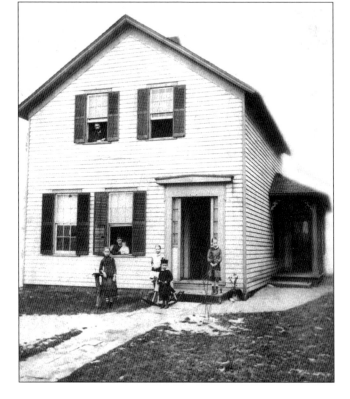

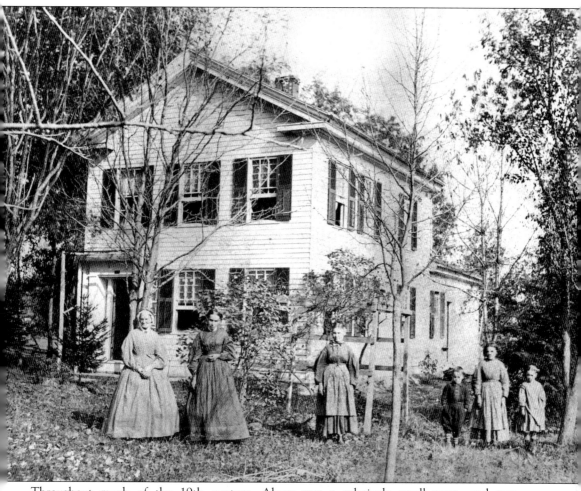

Throughout much of the 19th century, Akron was a relatively small town, and many neighborhoods retained their rural feel. This photograph shows Sara Gale in front of her home on West Exchange Street. The women are (from left) Sara Gale, her daughter Mary Gale McNeil, and "two other ladies." (Photograph courtesy Summit County Historical Society Collection.)

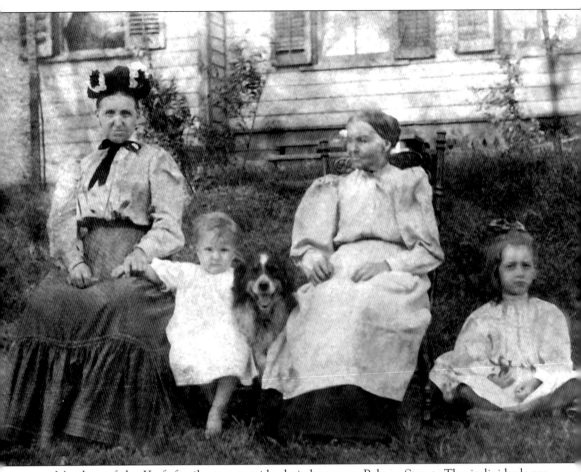

Members of the Kraft family pose outside their house on Palmer Street. The individuals are identified on the back of the photograph as (from left) "'Big Gram' Kraft, Helenov Marg. Kraft, 'Little Gram' Kraft, and Louisa Kraft." The Kraft family ran a bakery in Akron. (Photograph courtesy Janeanne Gregg-Huber.)

Ruth Mahan Fitt holds her first daughter, Patricia Grace. Born in 1892, Ruth was married to Ullysses Fitt, a lumberyard owner, and was 31 years old when Patricia was born. Ruth had attended a private school in Kentucky when she was younger and was a gifted tailor who supported her five children and her father following the death of her husband in 1934. (Photograph courtesy Patricia Graham.)

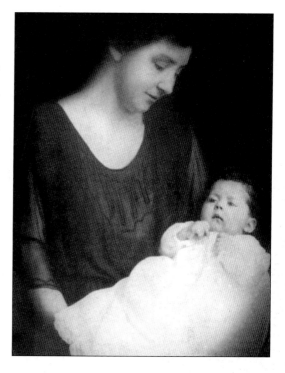

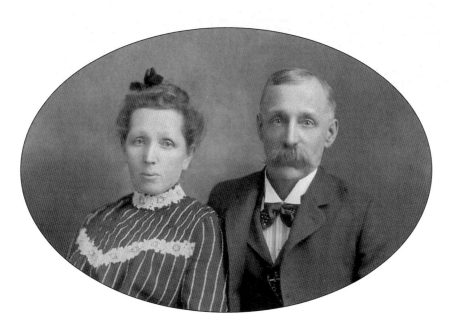

Louise (Meyers) and Calvin Spade lived their married life in Middlebury. Calvin learned the pottery trade from his uncle and became the foreman at the Robinson Clay Products plant near his home on Martha Avenue, now a part of the Goodyear Tire and Rubber Company's plant. This photograph was taken about 1890. (Photograph courtesy Donna Russell, great granddaughter of Louise and Calvin Spade.)

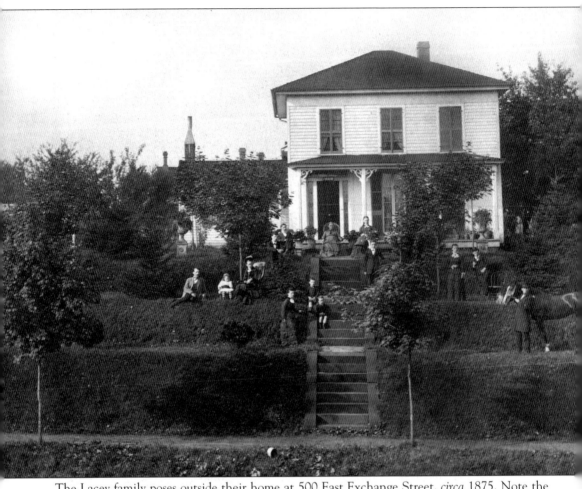

The Lacey family poses outside their home at 500 East Exchange Street, *circa* 1875. Note the matriarch of the clan rocking on the porch. (Photograph courtesy Summit County Historical Society Collection.)

Martha Murdock McKinney was only 25 when she emigrated from Ireland with her husband Thomas and their two daughters, Nancy, 3, and Margaret, 5 months, in 1856. The family settled initially in New York City, but, according to family stories, a priest advised them to leave the area. Thomas McKinney, a "staunch Orangeman," heeded the advice and moved to Middlebury, now part of Akron. In Middlebury, McKinney worked as a laborer. This photograph of Martha McKinney was taken at their home on Martha Avenue about 1880. (Photograph courtesy Donna Russell, great, great granddaughter of Martha McKinney.)

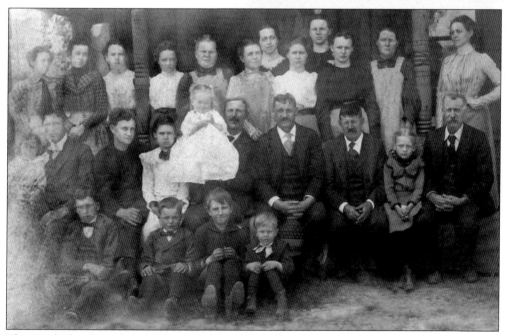

The Spade family included potters and farmers in East Akron. In 1891, some of the clan met for a reunion at the family house on Martha Avenue. (Photograph courtesy Donna Russell, a relative of the Spade clan.)

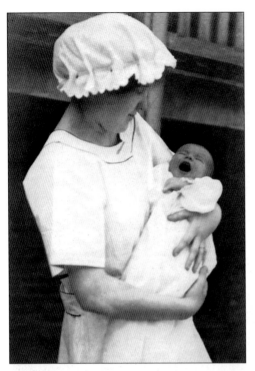

Helen Erdman-Hinderman and Joseph William Remark married in Akron in 1917. Two years later, their first child, William Joseph, was born—and, as this picture attests, both mother and child did fine. (Photograph courtesy Denise Remark Lundell.)

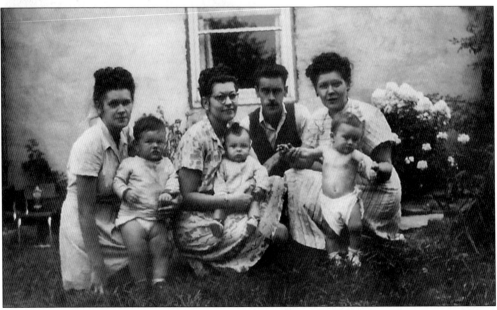

The Blinn sisters epitomized the toughness that grew out of conditions in Depression Akron. Marian (left) dropped out of Buchtel High School at age 16, traveled to Arizona with her brother George (shown), and for a time lived in mining camps. After she returned to Akron, she married Akron Rexall Drug Store pharmacist Tony Berneath. Doris (second from left) married St. Vincent High School star athlete Joe Haag and became a carpenter, planning and building the couple's home in Copley. Thelma (right) married and managed the family's "gas-and-grub" in Pennsylvania. (Photograph courtesy Jim McGarrity.)

Families in Akron came in all sizes, shapes, and varieties. Miss Ella Bradford (bottom) helped support her family when they moved up from Marietta during the Depression. Her family consisted of sister-in-law Bertha Pauline Johnson and her daughter Dorothy Eileen Johnson (pictured right in 1941). "Aunt Billie," as she was affectionately known, helped support the small family by working at the Firestone Tire and Rubber factory after Ella's half-brother left them. After the Johnson daughter married into the Quattrocchi family and had her own children, Aunt Billie was there to lavish her grand nieces with gifts. Aunt Billie is fondly

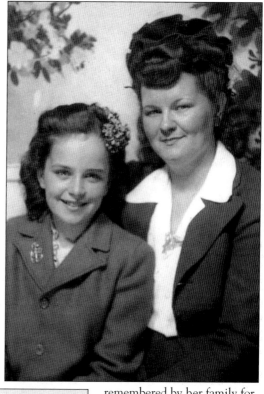

remembered by her family for her chiffon dresses, mink-trimmed slippers, rhinestone bat-wing glasses, her "tinted" permed hair, and her generosity. Ella Bradford died at the Little Forest Nursing Home in Akron in 1976. She was 81. (Photographs courtesy Tina Berisford and Dolli Gold, Bradford's great nieces and daughters of Pauline Johnson Quattrocchi.)

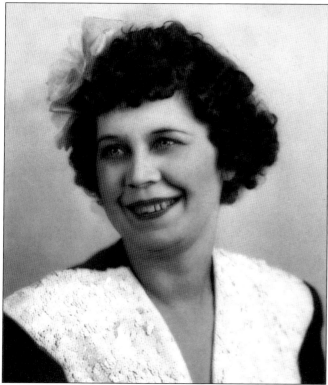

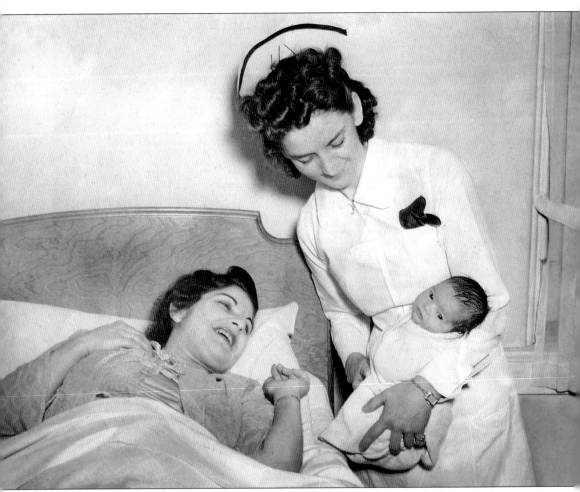

When Lillian Cohen had her daughter Arlene on Christmas Day, 1939, she made the news. It was the first birth that day. This photograph recorded the event. Here, Lillian welcomes her daughter Arlene at People's Hospital, now Akron General Medical Center. (Photograph courtesy Arlene Cohen Rossen, the baby pictured.)

The Ferise children—all 11 of them—pile onto the family car in 1941. The family lived on West Market Street, just west of Ross Drive, in the farmhouse set back from the street. (Photograph courtesy Denise Remark Lundell.)

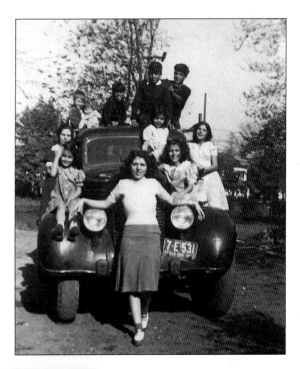

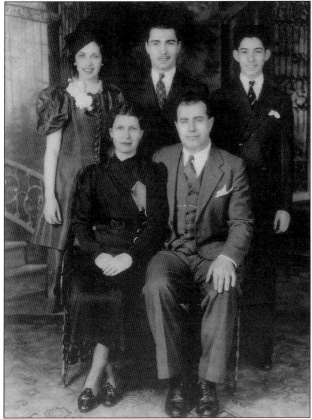

Meet the Rotilie family from North Hill, *circa* 1935. The family illustrates much about the Italian experience in Akron. The mother, the former Maria Dominica Antonucci, settled in Akron when she was only 13 years old. Orlando Rotilie came to Akron in 1913 when he was 19. Orlando got a job at General Tire and Rubber Company and found a room at the boarding house where Maria worked. The two met, fell in love, married at St. Martha's Catholic Church, bought a house in North Hill, and raised a family. The photograph shows (standing, from left) daughter Santana and sons August and Jack, with parents Maria and Orlando (seated). (Photograph courtesy Donna Dowler, granddaughter of Maria and Orlando.)

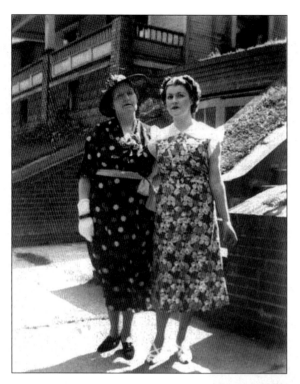

Clara Roberts Parks and her daughter Madeline Roberts stroll on the way to Christian Science Church services on Marshall Avenue one bright Sunday morning. Clara moved up to Akron from Parkersburg, West Virginia, before World War I. Her husband had come up earlier to find a job in one of the rubber factories and then sent for her and their two children once he was employed. In Akron, Clara took in boarders to supplement the family income. Clara and her husband divorced about five years after moving to Akron. She continued to support her children by taking in boarders and eventually remarried—to a rubber worker who had been one of her boarders. (Photograph courtesy Pamela Parks Costa, Clara's granddaughter.)

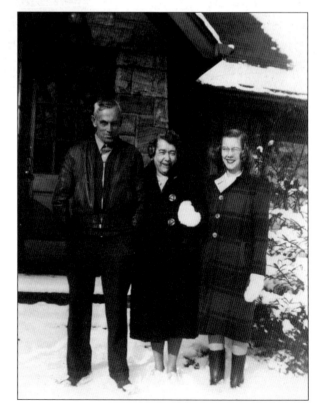

Meet a WPA family from the 1930s. Lawson Chase Drown, a teacher by training, could not find a job in Akron during the Depression. He was hired by the Works Progress Administration (WPA) and assigned the job of caretaker at Forest Lodge, at the intersection of Mull Avenue and South Hawkins. The family—he, his wife Anna Helen, and daughter Janet (pictured at Forest Lodge)— were allowed to stay at the cottage. As part of his duties, Lawson flooded the skating area and maintained it throughout the winter. To earn extra money, his wife sold candy and hot chocolate at the concession stand. (Photograph courtesy Denise Remark Lundell, granddaughter of Lawson and Anna Helen.)

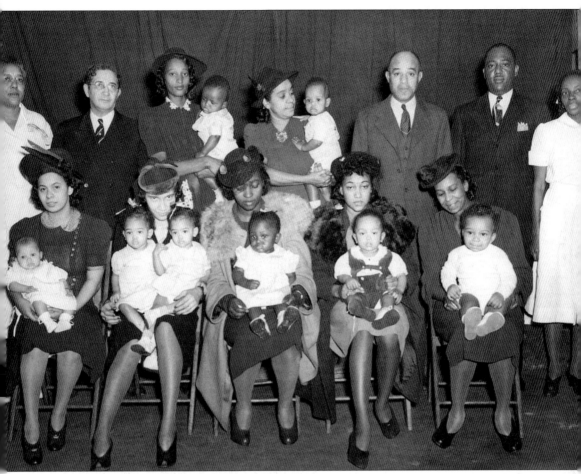

There's nothing like a baby contest to bring out the cutest children in town. This photograph was taken at a contest during the 1940s. No winner was recorded on this photograph; perhaps the decision was too difficult. (Photograph courtesy Sam Shepard Collection.)

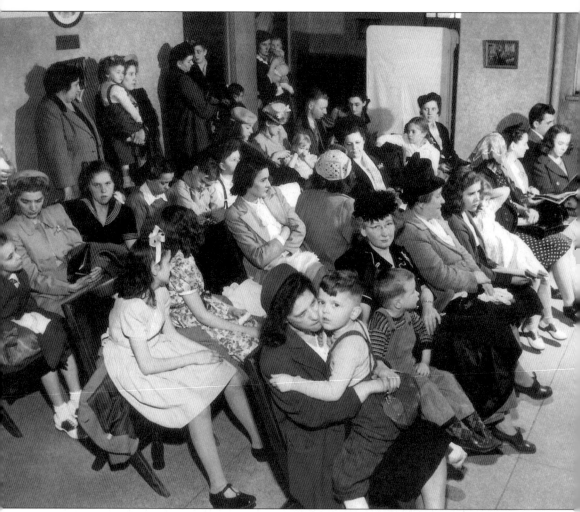

Throughout much of Akron's history, women have had primary child-care responsibilities. The waiting room at the Children's Clinic at Children's Hospital during World War II illustrates that principal. Mothers accompany almost every child. (Photograph courtesy of Children's Hospital Medical Center of Akron.)

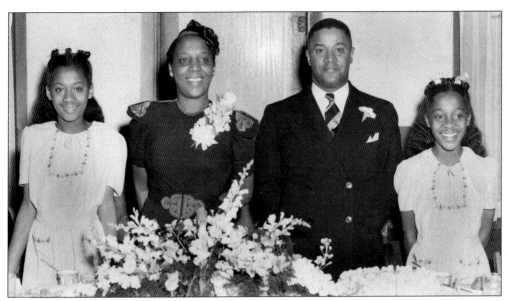

The Reverend Stanley and Remonia Lynton pose with their two daughters, Gwendolyn and Winifred. Lynton was the pastor at Second Baptist Church. They lived at 203 East Buchtel. (Photograph courtesy Sam Shepard Collection.)

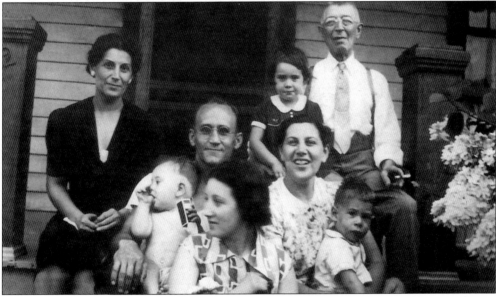

Three generations of Gilbloms pose outside a Firestone Park home. They are (front row) Jean Gilblom; (second row, from left) baby Richard Reymann, his father and mother, Martin and Anne Gilblom Reymann, and their other son Jerry; and (back row) Myrtle Langman Gilblom, matriarch of the clan, her granddaughter Phyllis Reymann, and Meyer Gilblom. Myrtle and Meyer Gilblom came to Akron from Pennsylvania during the early 1920s when the rubber companies needed workers. Meyer found a job at Goodyear Tire and Rubber Company soon after arriving. Myrtle and Meyer Gilblom, whose marriage had been arranged by their parents, eventually separated but never divorced. (Photograph courtesy Mary Ellen, Jean Ann, and Richard R. Reymann, and Phyllis Reymann Bruno, children of Anne and Martin Reymann.)

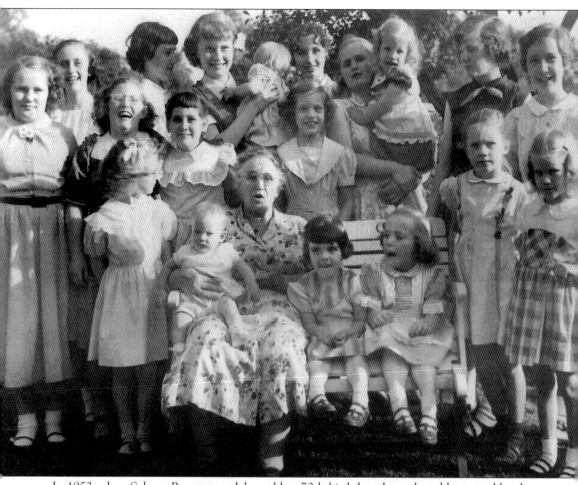

In 1952, when Salome Reymann celebrated her 70th birthday, she gathered her granddaughters round her, and this photograph was taken. They are (front row, from left) Eileen, Salome Reymann holding Kathleen, Roberta, Rosemary, and Lucille; (second row) Carol Louise, Isabelle, Jean, and Diane; and (third row) Rita, Phyllis, Selma holding Collette, Joan Lindsay, Marcia holding Michelle, Mary Beth, and Terry Lindsay. (Photograph courtesy Jean Ann Reymann.)

Meet the three Spade sisters, *circa* 1950. Lillie Spade Pfeiffer (left) started working in Goodyear Tire and Rubber Company's factory office around 1905 and continued to work there until she married—30 years later. Younger sister, Carrie Spade Krumroy (center) eventually moved to Tallmadge, near Akron. Louise Spade Ody (right) married in Akron, but eventually she and her husband bought a farm in Windham, Portage County. The Odys lost that farm during the Great Depression. (Photograph courtesy Donna Russell, granddaughter of Louise Spade Ody.)

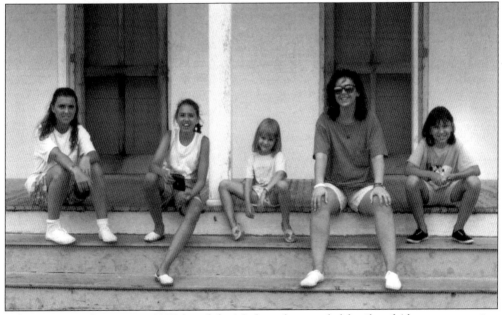

A lazy summer afternoon in 1987 found the Markovich extended family, of Akron, on vacation on the Outer Banks of North Carolina. They are (from left) Rachel, Gayle, Elizabeth, Amanda, and Meghan Markovich. (Photograph courtesy of Dolli Quattrocchi Gold, the mother of Gayle, Elizabeth, and Meghan.)

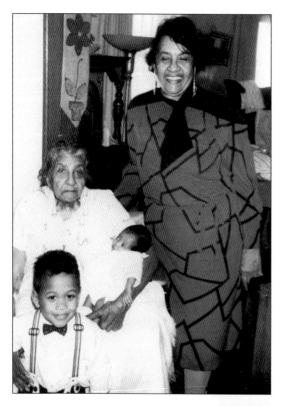

Family has always been a great source of comfort and strength within the African-American community in Akron. Here, four generations enjoy each other's company. Matriarch seated is Levater Averiett Colvin, holding her great granddaughter Rebecca Wilson. Standing is Juanita Colvin, and in the front is grandson Frederick Sadler. (Photograph courtesy Cheryl Sadler, mother of Frederick and daughter of Juanita.)

Meet a new face in the immigration history of Akron—the Hmongs. The Hmongs are farmers from the mountainous region of Northern Laos. Since 1979, Akron's International Institute has resettled nearly 600 Hmong families; 400 families continue to live in the Akron area. (Photograph courtesy International Institute.)

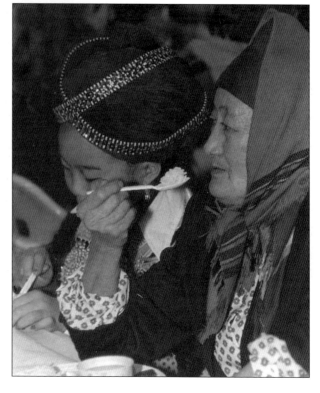

Five

WORK

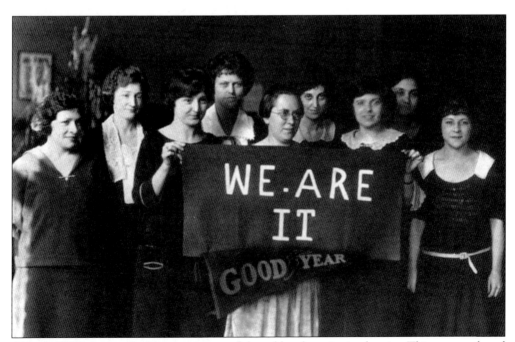

Akron's YWCA opened chapters at most of the rubber factories in the city. This one was based at Goodyear Tire and Rubber Company, and the women were proud of their affiliation with the "Y." (Photograph courtesy YWCA of Summit County Collection.)

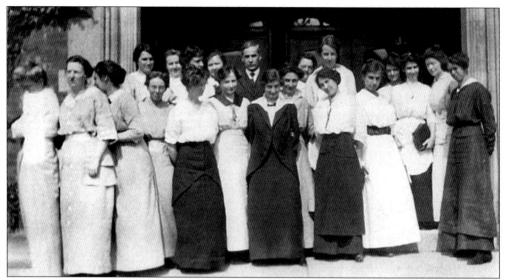

Teaching was always considered an "acceptable" occupation for young, unmarried women. Most of the teachers in Akron's public schools were women. This photograph shows the teachers at Lane Elementary School during the 1914–15 academic year. One of those teachers was Elizabeth Frantz (front row, second from left). (Photograph courtesy Gail James, who continues to search for descendants of Elizabeth Frantz.)

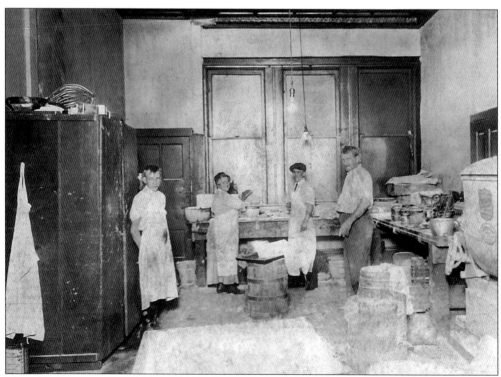

Mary Kraft was vital to the success of the family business, Kraft Bakery, even though she was not paid. Here, Mary (second from left) helps with the baking with other family members. (Photograph courtesy Janeanne Gregg-Huber, Mary's great, great granddaughter.)

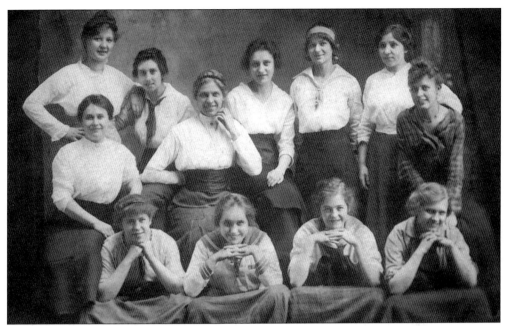

Women held many jobs in Akron's rubber factories before World War I. Some of the women were immigrants; others were native born. The "Zipper Girls," who worked in Department 25 of B.F. Goodrich Company, are identified as (front row, from left) Isabel Nye, Anna Gish, Mary Riel, and Esther Swigart; (second row) Lucy Derhammer, "Big" Rose, and unknown; and (back row) "Lydia Koromnow Pastor," Thelma Eaton, Minnie Horn, Margaret Rittig, and Ann "last name forgotten." (Photograph courtesy B.F. Goodrich Collection.)

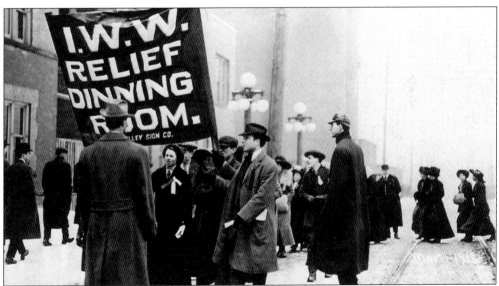

In February 1913, an estimated 15,000 Akron rubber workers walked off the job in a bitter strike organized by the Industrial Workers of the World (Wobblies). Women workers who walked away from their jobs worked in the relief dining room with the wives and daughters of the striking men. The strike lasted about five weeks and brought few changes to the labor conditions in the rubber factories. (Photograph courtesy the University of Akron Archives.)

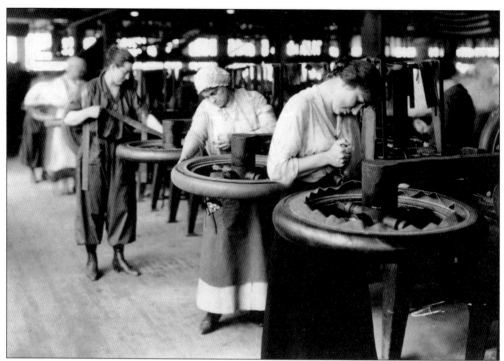

Women were employed in many different jobs at the rubber factories, including tire building. (Photograph courtesy the Goodyear Tire and Rubber Company Collection.)

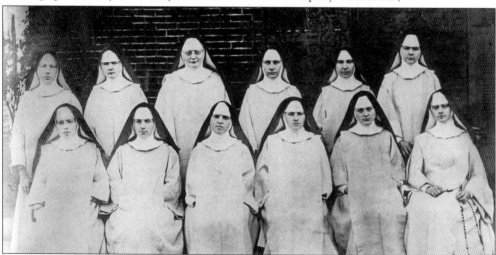

In 1893, the Caldwell Dominican sisters came to Akron to teach German Catholic students enrolled at St. Bernard's School. The original 12 nuns were sisters (seated, from left) Thomasine, Beda, Hieronime, Scholastica, Aloysius, and Agnes; and (standing) Jordani, Gonzaga, Alacoque, Yolanda, Hildegarde, and Norberta. If not all the nuns are smiling, that may reflect the living conditions they faced in Akron. The 12 lived initially in the basement of the church and then moved to the "house by the [railroad] tracks." In 1905, the order opened Sacred Heart Academy, an all-girls secondary school, across the street from St. Bernard's Catholic Church. In 1923, the sisters opened Our Lady of the Elms, all-girl elementary and high schools that still operate in the city. (Photograph courtesy Sisters of St. Dominic.)

Quaker Oats traces its history back to Akron and Ferdinand Schumacher's cereal mills. In Akron, women always figured in cereal production. Here, a few of the "Quaker Girls" pose for a snapshot in 1900. According to newspaper accounts of the day, Miss Lou Downs was the head forelady and Miss Etta Triplett (front center) was assistant forelady. (Photograph courtesy Kathleen L. Endres.)

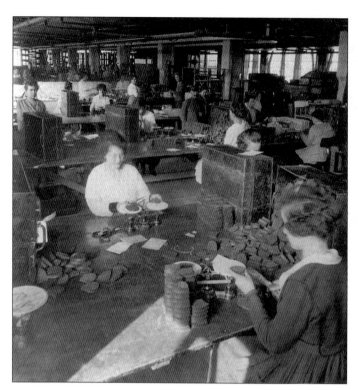

In the early 20th century, the rubber factories in Akron produced much more than tires, and women were involved in the manufacture of many of these products. Here, the women of the Goodyear Tire and Rubber Company work in the boot and shoe department. (Photograph courtesy Goodyear Tire and Rubber Company Collection.)

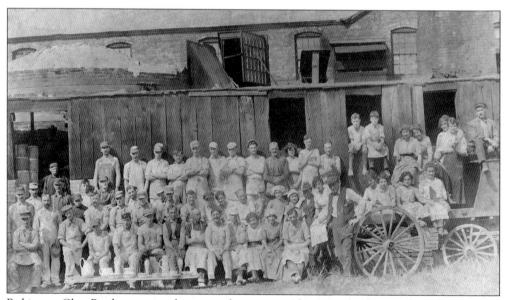

Robinson Clay Products was a key manufacturer in Akron in the late 19th and early 20th centuries. This photograph, taken around the turn of the century, shows the workers at the pottery, including a number of women. (Photograph courtesy Donna Russell, whose great grandfather was the foreman at the facility.)

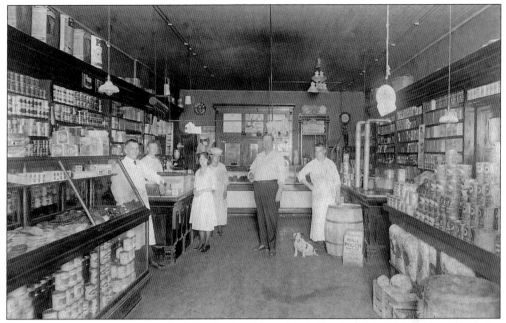

Women shop at the Rech Grocery Store, located on South Main Street in 1892, the approximate date of this photograph. (Photograph courtesy Janeanne Gregg-Huber, great, great granddaughter of the Rechs.)

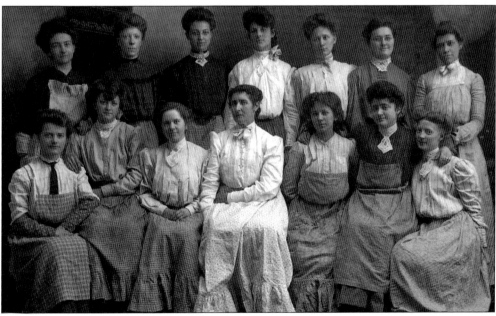

These unidentified women workers from the American Hard Rubber Company pose for a company picture. (Photograph courtesy Akron-Summit County Public Library, Special Collections.)

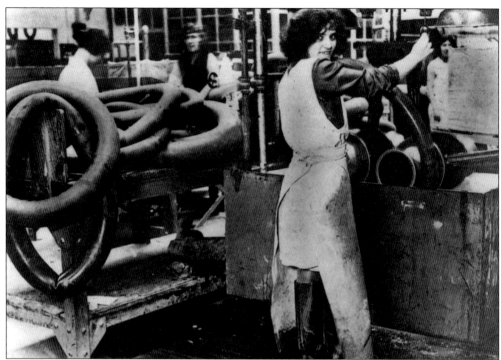

Many Akron flappers traded in their dancing shoes for more sensible attire during the workday. Here, two sets of flappers show another version of 1920s Akron. The Goodyear Tire and Rubber Company flapper (top) found that work in the factory—while lucrative by standards of the day—could be physically taxing and dirty. The Ohio Bell flappers (below) might not have faced the grime of the factory, but did not earn as much. Here, Ohio Bell workers Charlotte Nunn, Pfarr, Kennedy, Limmons, and Gruska wait for a streetcar to take them to work. (Photographs courtesy Goodyear Tire and Rubber Company Collection and the Bev Coss Photograph Collection.)

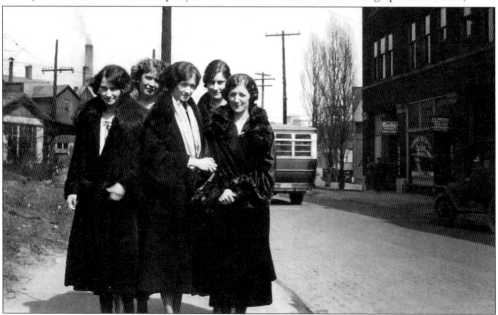

Although the U.S. Census may not have counted her as an employed woman, Edith Mae Hoffmeyer worked in her husband's store, H&O Grocery in Highland Square, in the 1920s and 1930s. The couple had moved to Akron from Pennsylvania with their children and his two sisters, Edith and Mary, in 1923. Edith cared for the children while Edith Mae worked at the grocery store, and Mary worked as a seamstress at Polsky's Department Store. (Photograph courtesy June Roberts, daughter of Edith Mae and Robert Hoffmeyer.)

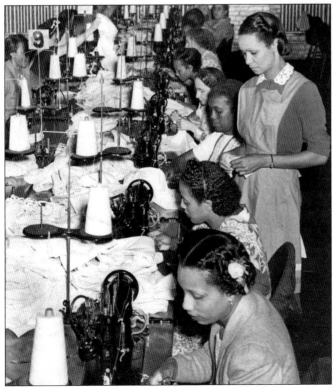

Loretta Goodwin supervises women in a WPA project in Akron in the 1930s. The women were sewing clothing donated to the needy in the city. (Photograph courtesy Sam Shepard Collection.)

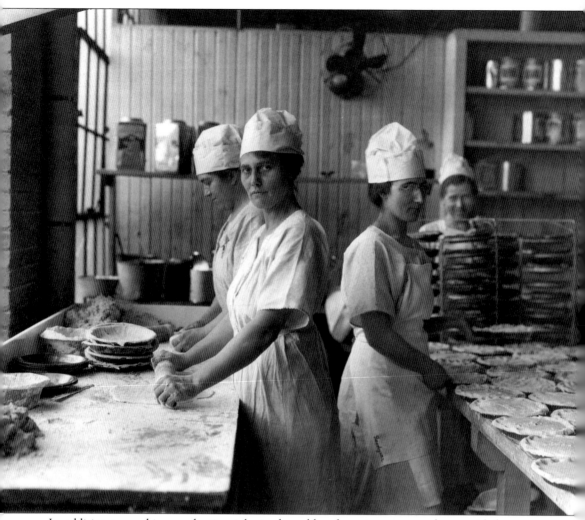

In addition to working production jobs in the rubber factories, women also provided support services. Here, women prepare pies available at the factory cafeterias. (Photograph courtesy Goodyear Tire and Rubber Company Collection.)

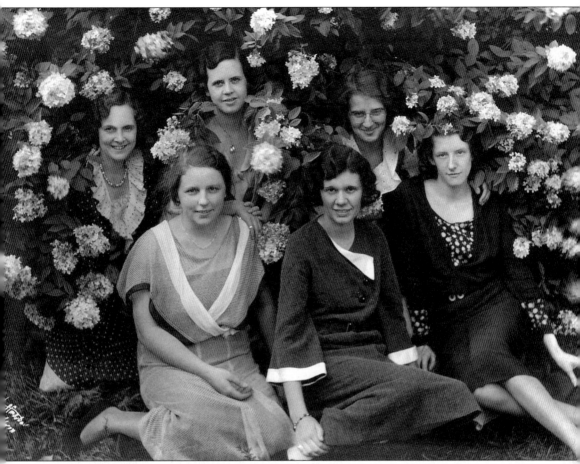

Who says librarians are stern, elderly matrons? This photograph from the 1920s shows the staff of the Public Library, posed outside one sunny summer day in Akron. (Photograph courtesy Akron-Summit County Public Library, Special Collections.)

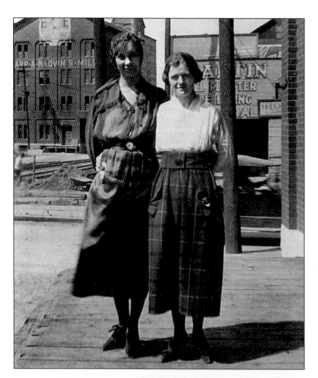

Two unidentified women pose outside the office where they worked. (Photograph courtesy Kathleen L. Endres.)

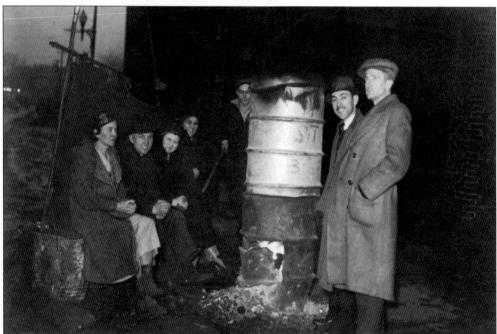

The rubber workers at Goodyear Tire and Rubber, B.F. Goodrich, and Firestone Tire and Rubber organized in the United Rubber Workers Union. Because so many women were employed in Akron rubber factories, they walked the picket lines. Here, Goodyear Tire and Rubber Company employees—female and male—huddle around the fire during the bitter strike of 1936. (Photograph courtesy Goodyear Tire and Rubber Company Collection.)

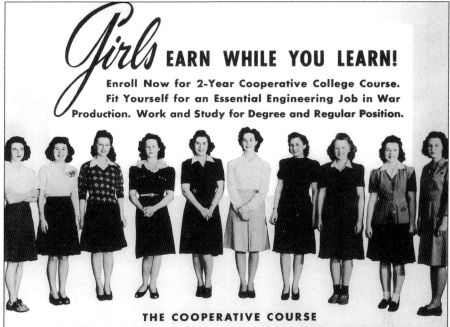

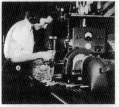 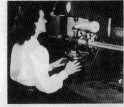

During World War II, Goodyear Aircraft recruited women into engineering jobs by offering training through the University of Akron and the University of Cincinnati. At the end of training, women earned an engineering certificate and a good paying, albeit temporary, job at Goodyear Aircraft. When the men returned from war, women who held engineering jobs lost their positions. (Poster courtesy Kathleen L. Endres.)

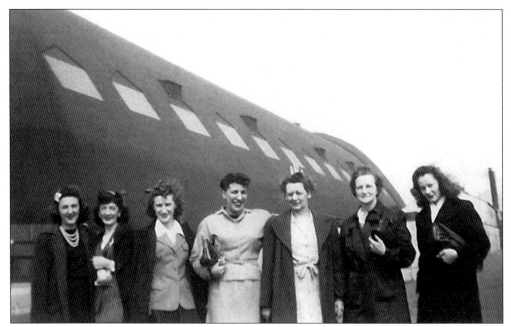

During World War II, the world famous Goodyear Airdock was used as a site for the production of aircraft. These seven unidentified women are just some of the thousands who worked there during the war. (Photograph courtesy Kathleen L. Endres.)

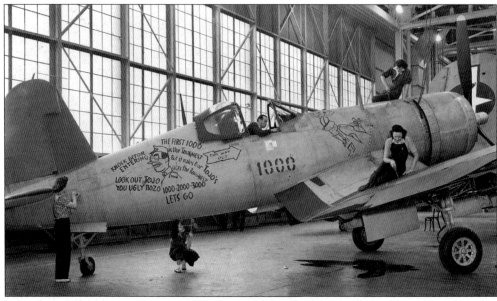

During World War II, Akron became a center of aircraft production. In January 1942, only one woman worked at Goodyear Aircraft. By 1944, almost 45 percent of the employees were women. Goodyear Aircraft was best known for its production of the Corsair during World War II. (Photograph courtesy Goodyear Tire and Rubber Company Collection.)

Everyone who worked in the tire factories during World War II had to wear a badge that carried an identification photograph. This unidentified woman worked for the B.F. Goodrich Company. (Photograph courtesy Kathleen L. Endres.)

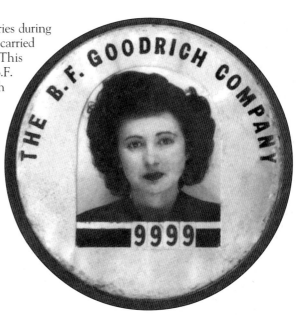

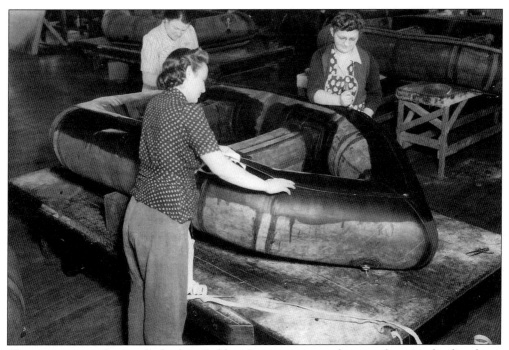

Three women workers at Seiberling Rubber Co. cement a seal on a submarine landing boat. These boats did not sink even if holes were shot in one or more compartments. (Photograph courtesy Kathleen L. Endres.)

Joan Guinter Orr had one of the more glamorous jobs in Akron in 1944. She worked as a model at the downtown O'Neil's Department Store. She'd wear the latest fashions as she strolled through the Georgian Room, a restaurant in the store. But she found that onlookers didn't keep their comments about the clothes she wore to themselves and often critiqued her as well. (Photograph courtesy Judy James, Joan's daughter.)

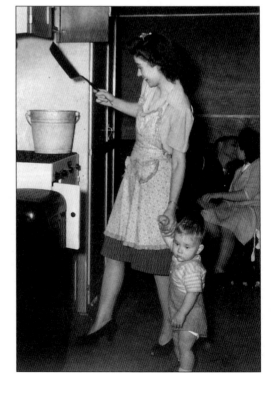

When her husband Frank enlisted in the Navy during World War II, Lucrete Endres stayed home in Akron and gave birth to their son Fred. When Frank's ship docked after his tour, Lucrete headed for Norfolk, Virginia, with her son in tow. Here, she prepares a meal in a primitive trailer the family rented in Virginia. After the war, the family ran Bon Ton Bakery on Lover's Lane in Akron. (Photograph courtesy Lucrete Endres, who still lives in Akron.)

Like almost any Thanksgiving in Akron in the 1940s and 1950s, women had responsibility for cooking the big meal and cleaning up afterwards, while the men relaxed, smoked cigarettes, and listened to the football game on the radio. That's what happened when this photograph was taken in the home of Hazel and Clifford Orr. The women are (from left) Marie Myers, Joan Guinter Orr, Lucille Hostetler Orr, and Rita Siebanoller Orr. The latter three were married to the Orr brothers. Marie Myers was the unmarried sister of Hazel Orr. (Photograph courtesy Judy James.)

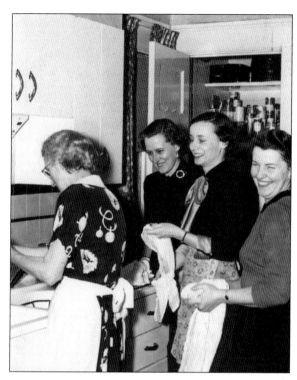

Helen Stocking Waterhouse was the "most controversial newspaperwoman in Akron history," according to the Beacon Journal. In her long reporting career at the Beacon, she covered many key stories, including the trial of Bruno Hauptman, accused of kidnapping and killing the son of pilot Charles Lindbergh. She also covered the Hindenburg disaster in Lakehurst, New York. (Photograph courtesy Akron-Summit County Public Library, Special Collections.)

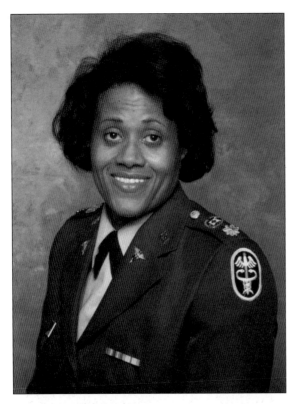

Cheryl Sadler, a faculty member in the College of Nursing at the University of Akron, is also a member of the Army Nurse Corps, 256th Combat Support Hospital, Brooklyn, Ohio. She also served with the 2291st Hospital Unit at Woodford Army Reserve Union, Akron. During Desert Storm/Shield, she was the head nurse of the obstetrical/gynecology clinic at Blanchfield Army Medical Center with the 101st Airborne at Ft. Campbell, Kentucky. (Photograph courtesy Cheryl Sadler.)

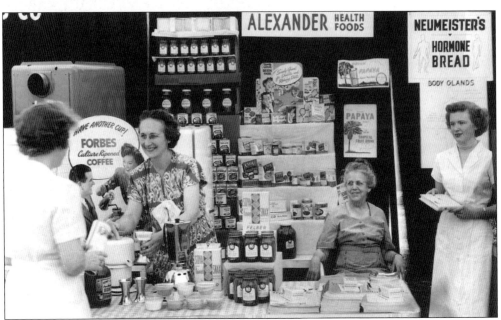

Celeste May (Snyder) Alexander, seated in the photograph, started her health food business, Alexander Health Foods, in Akron in 1938 and ran it for decades. Her store was located at the corner of Cherry and South Howard Streets in downtown Akron. (Photograph courtesy Margaret Alexander, Celeste's daughter.)

Six
COMMUNITY LIFE

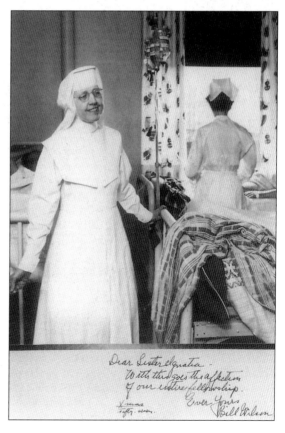

Sister Ignatia Gavin, responsible for admissions for St. Thomas Hospital in Akron in 1935, is given credit for admitting the first alcoholic for medical treatment. That move made history. The alcoholic was admitted under the diagnosis of acute gastritis, and St. Thomas became the first hospital in the nation to treat alcoholism as a medical condition. This photograph was taken in 1957 in the alcoholic ward of the hospital. It carries an inscription of gratitude from Bill Wilson, one of the founders of Alcoholics Anonymous. (Photograph courtesy Sisters of Charity of St. Augustine.)

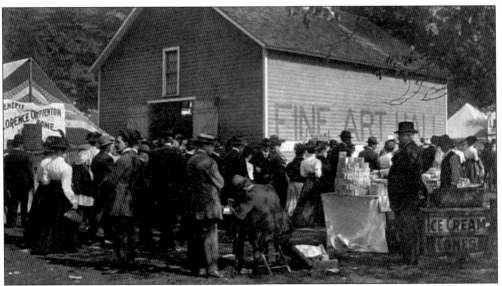

Dula Harter Guinter was like many Akron women who were committed to their church. She sang in the choir and belonged to a number of service and missionary groups affiliated with First Methodist Church. Dula also joined the Woman's Christian Temperance Union, which had chapters throughout Akron during the early 20th century. (Photograph courtesy Judy James, Dula's granddaughter.)

This fundraiser at the Summit County Fair Grounds benefited the Florence Crittenton Home in Akron. The Florence Crittenton Rescue League ran two homes. "Incorrigible girls" who showed promise went to the Cotter Street facility. Unwed mothers went to the maternity home on Brittain Road. (Photograph courtesy Summit County Historical Society.)

Ruth Wheeler, daughter of the founder of the YWCA in Akron, served as general secretary in 1904. Here, she is pictured outside an early YWCA office in the Wilcox Building on South Main Street. (Photograph courtesy YWCA of Summit County.)

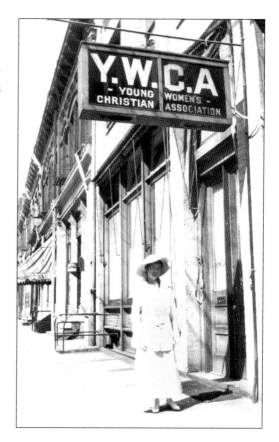

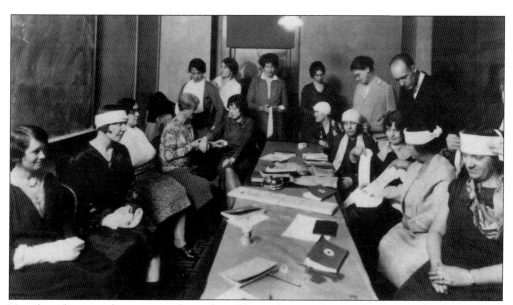

No, this photograph was not taken of an Akron disaster. It was the First Aid Class, School of Adult Education, at the YWCA, *circa* 1930. (Photograph courtesy YWCA of Summit County Collection.)

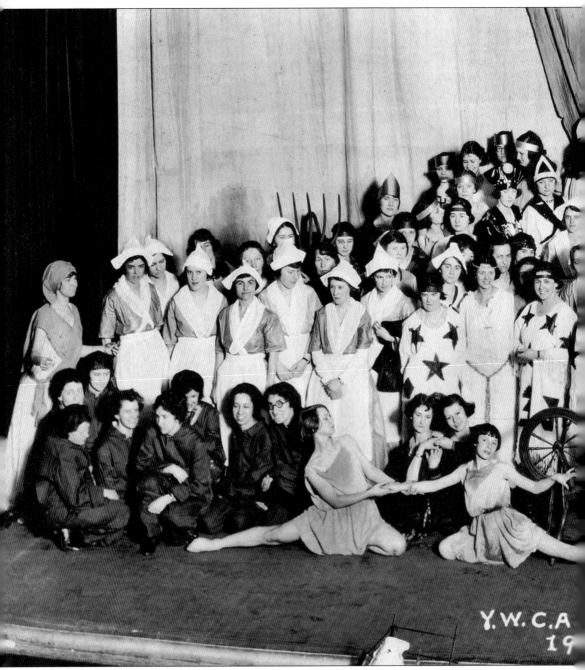

During the 1920s and 1930s, many community groups organized pageants for fun and for fundraising for worthy causes. In 1922, the women of the YWCA staged this pageant at the

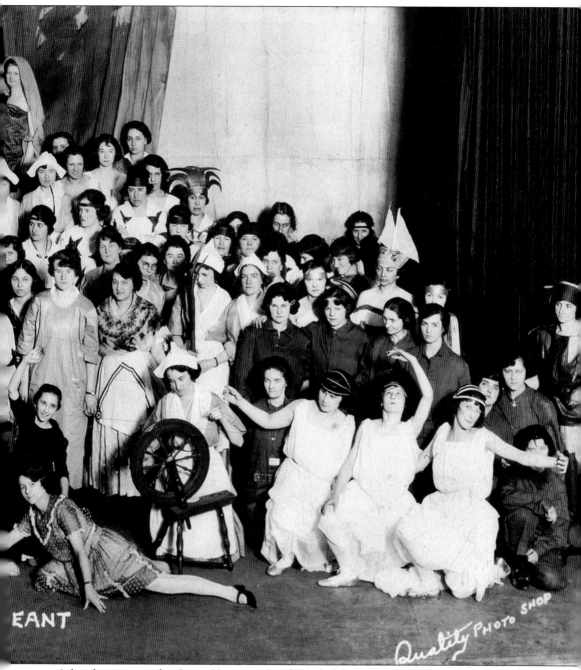

EANT

Quality PHOTO SHOP

group's headquarters at the Grace House on South High Street. (Photograph courtesy YWCA of Summit County Collection.)

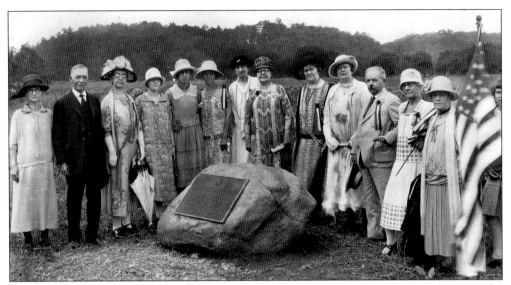

Many women's groups were involved in the city's celebration of its centennial. Here, the Daughters of the American Revolution (DAR) pose at the dedication of the boulder at the northern terminus of the Portage Trail, July 23, 1925. They are identified as follows (from left): Mrs. Joseph Courtney, Joseph Courtney (who donated the land), Mrs. A.E. Heintzlerman, Helen Esther Hay, Jane Mattle or Wattleworth, Edith Hurlbut (chair of the Boulder Committee), Mrs. F.Y. Hay (past regent, DAR), Mrs. S.A. Kepler (regent, DAR), Mrs. Hobart (Cincinnati regent), Mrs. Dailey (state historian, Athens, Ohio), F.A. Seiberling (member, Metropolitan Park Board), Mrs. Burnett (past custodian), and Mrs. Morse (chaplain). (Photograph courtesy Summit County Historical Society Collection.)

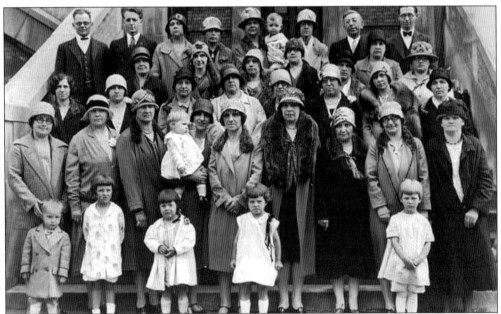

Shortly after the Home and School League was established in Akron, the mothers of students at Zion Lutheran School organized their own chapter. This is the 1929 Zion Home and School group. (Photograph courtesy Zion Lutheran Church.)

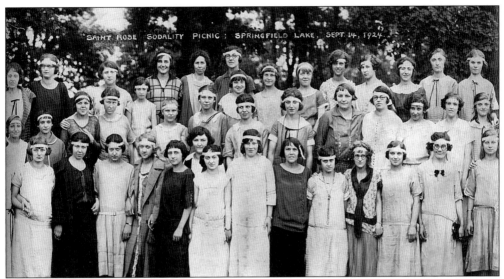

Members of St. Bernard's St. Rose Sodality, an organization of young single Catholic women, enjoy a picnic at Springfield Lake on September 14, 1924. (Photograph courtesy St. Bernard's Catholic Church.)

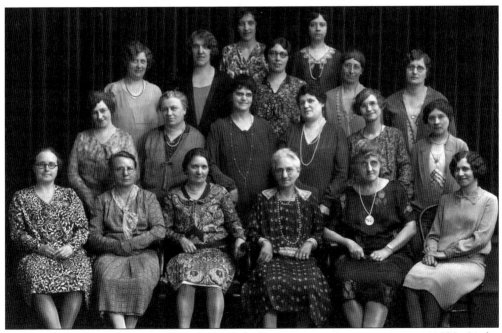

Zion Lutheran Church on South High Street had many women's organizations in 1929. At the India Sewing Club, the women sewed for the missions. The women are as follows (from left): (front row) Mrs. E. Noack, Mrs. A. Piske, Mrs. A. Fichter, Mrs. A. Perschonke, Mrs. A. Haberkost, and Mrs. C. Newman; (second row) Mrs. G. Koch, Mrs. O. Graf, Mrs. G. Ringhand, Mrs. A. Wegmueller, Mrs. G. Winebrenner, and Clara Gohlke; (third row) Mrs. D. Cahow, Mrs. E. Gibson, Mrs. C. Spiegel, Mrs. A. Schneider, and Mrs. Bauer; and (fourth row) Mrs. G. Arkebauer and Mrs. W. Friedrich. (Photograph courtesy Zion Lutheran Church.)

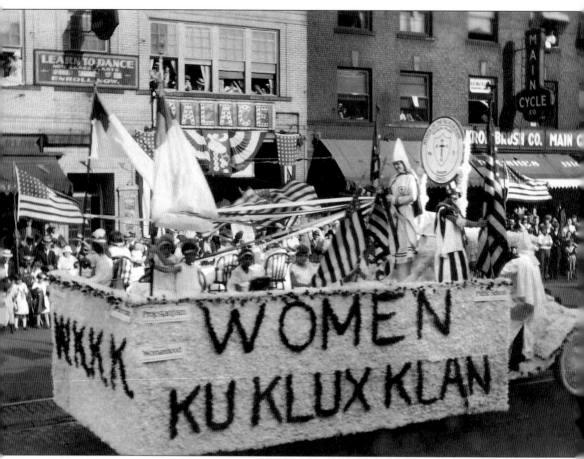

By 1925, Akron had one of the largest Ku Klux Klan chapters in the nation. Female relatives of those members formed auxiliaries to the group. During Akron's 1925 centennial parade, the Women of the KKK had a float that applauded "Protestantism," "Womanhood," and "Public Schools." (Photograph courtesy Akron-Summit County Public Library, Special Collections.)

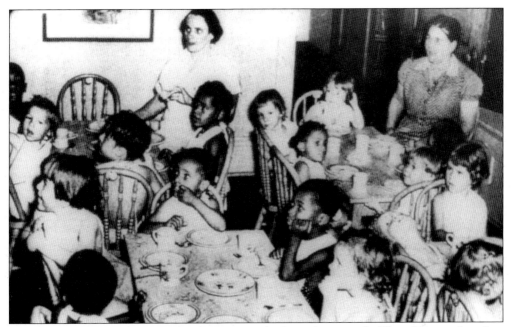

The pre-schoolers at the Mary Day Nursery settle down for a snack. This photograph, taken about 1927, illustrates the popularity of the day-care facility in Akron. This was also a time of transition for the nursery. In 1926, the management of nursery shifted from Children's Hospital to the Junior League, who continued it as the Katharine McLain Knight Nursery until 1938. (Photograph courtesy Children's Hospital Medical Center of Akron.)

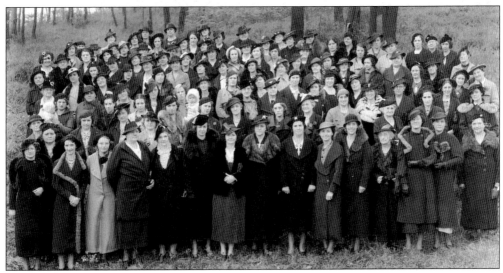

Throughout Akron history, the church has been a central focus in the lives of many women in the city. Through Bible classes, missionary societies, and ladies' aid groups, Akron women have enjoyed a special fellowship. Here, the Ethel Binford Bible Class of the Arlington Street Baptist Church poses for a photograph in 1936. (Photograph courtesy Mary Boley, whose mother was a member of the Bible class.)

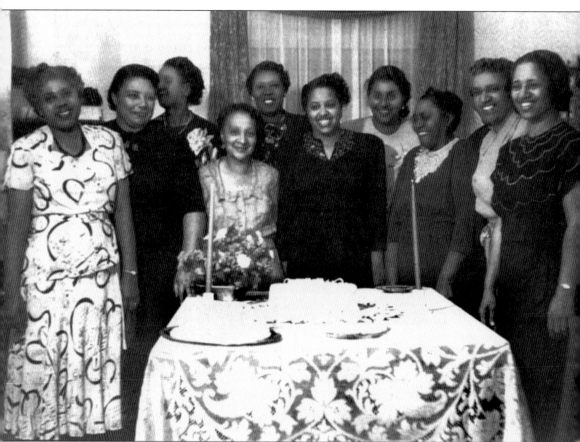

The Blue Flame Club was an African-American women's club that helped elderly women of all races during the 1930s. Each month, they met at a member's home, where they shared food, conversation, and plans for their benevolent work. From left to right are Louise Barnett, Beatrice Edgerton, Sadie Scruggs, Louise Grant, Rosetta McGhee, Nellie Meade, Willie Lett, Levater Colvin, Alfreda Singer, and Jessica Whitaker. (Photograph courtesy Cheryl Sadler, Levater Colvin's granddaughter.)

During World War II, Akron women got involved in "homeland security." This is the identification card of Minnie Lavina Baxter of 534 Avalon Avenue. She was a senior warden of the Citizens Defense Corps in Ward 4, Precinct E, Sector 1. (Photograph courtesy Marie Van Meter, Minnie Baxter's granddaughter.)

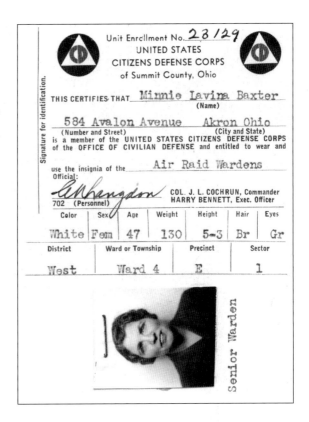

The Iota Phi Lambda sorority served as a networking, motivational, and mentoring group among African-American women in the city. This photograph from the 1940s shows some of the Akron members. They are (from left) Mary Hall, Mabel Long, Vera Day, Juanita Wseley, Theodosia Skinner, Hattie Dykes, Mildred Miller, Juanita Colvin, and Georgia Hammitt. (Photograph courtesy Sam Shepard Collection.)

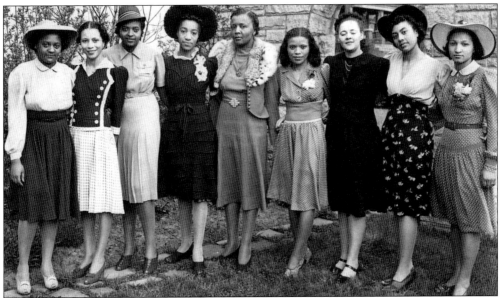

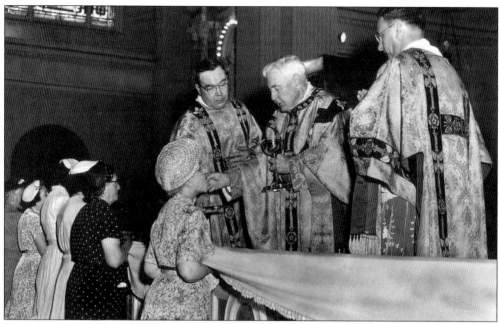

From the beginning, women were vital to the survival of every religious community in the city. They organized clubs and organizations to support the church, temple, or synagogue. Here, Bishop Edward Hoban of Cleveland gives Holy Communion to a woman at St. Bernard's Catholic Church in the 1950s. (Photograph courtesy St. Bernard's Catholic Church.)

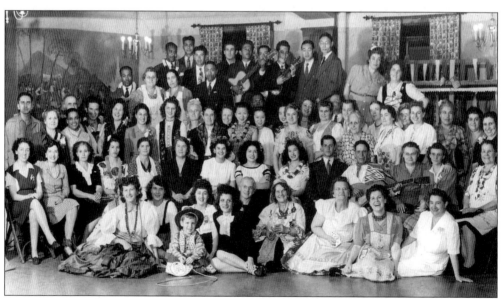

The International Institute, created as an arm of the YWCA during World War I, provided key services to the changing immigrant community in Akron. Here, men and women from 17 different national, ethnic, and racial backgrounds participate in the "World Fellowship Roundup," November 2, 1945. About two years later, the International Institute split from the YWCA in a bitter dispute. (Photograph courtesy International Institute.)

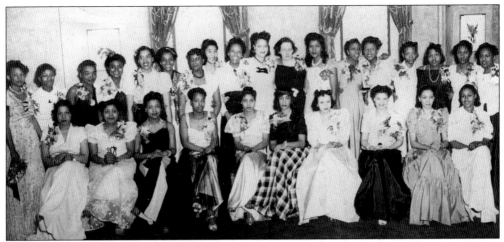

Women's clubs and organizations in Akron did not always welcome women of color. The YWCA of Akron was no exception. It was not until 1950 that the group's board of directors approved opening all facilities to anyone regardless of race. Prior to that, African-American women were allowed to join the YWCA but organized their own clubs, like the Framulea Club (pictured above) under the direction of Miss Munn in 1942. (Photograph courtesy YWCA of Summit County Collection.)

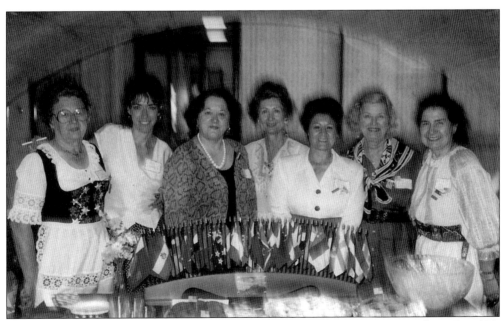

For years, the International Institute hosted the New Citizens' Reception in Akron. In 1990, those serving as hosts were (from left) Alma McDougall (Austria), Judy Sanders (USA), Magdalena Moosairan (Hungary), Demetra Ecconba (Greece), Betty Delgado (Ecuador), Sue Themely (Greece), and Cornelia Aro (Romania). (Photograph courtesy International Institute.)

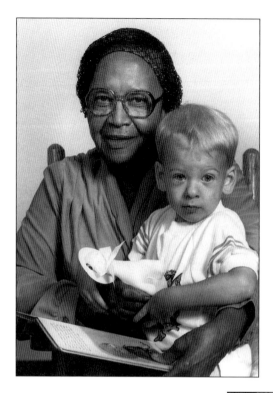

United Disability Services relies on volunteers to add the extra tender care to the children it serves. Here, "Grandma" Odena Love reads to little Justin Crites. (Photograph courtesy United Disability Services of Akron.)

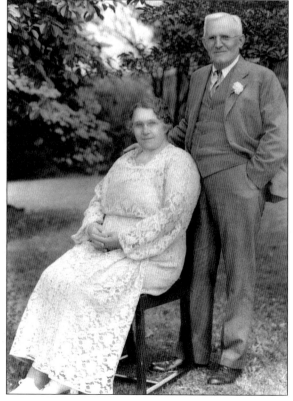

In the mid 1950s, Charles and Salome Reymann could look back on a long and fruitful life. Charles ran Akron's successful Atlantic Foundry, and Salome raised 16 children. The couple is credited with helping to found St. Matthew's Parish. As Catholics, they were not welcomed into their Canton Road neighborhood when they moved there in 1918. Salome recalled that one summer day when she was hosting an ice-cream social to benefit the Catholic Church, the Ku Klux Klan burned a cross in their orchard. (Photograph courtesy Mary Ellen, Jean Ann, and Richard R. Reymann, grandchildren of Charles and Salome.)

This campaign poster reminded Akronites to give to the city's Children's Hospital. Women started the hospital and were a key to its continued success. As the poster asserts, "Watch For The Woman With The Pledge Card." (Poster courtesy Children's Hospital Medical Center of Akron.)

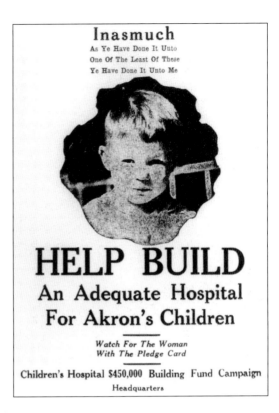

Akron's African-American community had many women's clubs and organizations. This is the Northeast Ohio Colored Women's Club that was based in Akron. The photograph carries no identifications of the women. (Photograph courtesy Sam Shepard Collection.)

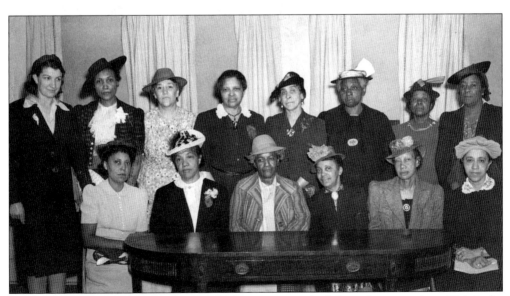

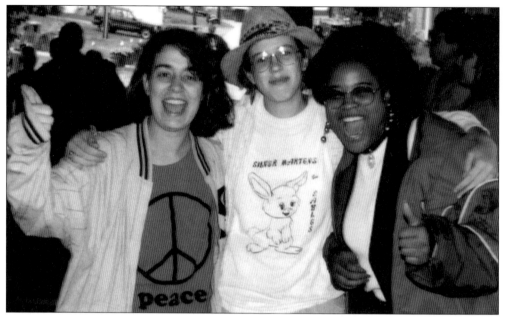

Every October for decades, the YWCA has hosted the "Take Back the Night" rally and march to raise awareness of domestic violence and sexual assault. In the late 1990s, these three unidentified women joined the festivities. (Photograph courtesy YWCA of Summit County Collection.)

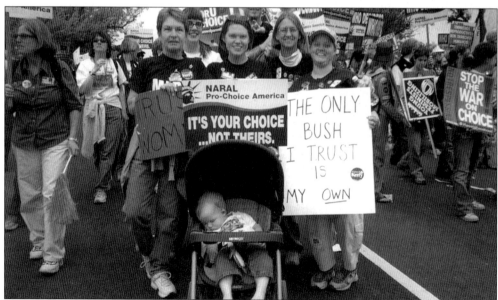

Four generations of Akron women went to Washington, D.C., in 2004 to march for reproductive rights. They are, from left, Phyllis, Brittany, Sydney, and Bethany O'Connor. Brittany is pushing Sydney O'Connor Heckeler. (Photograph courtesy Phyllis O'Connor.)

Seven

ENTERTAINMENT
AND SPORTS

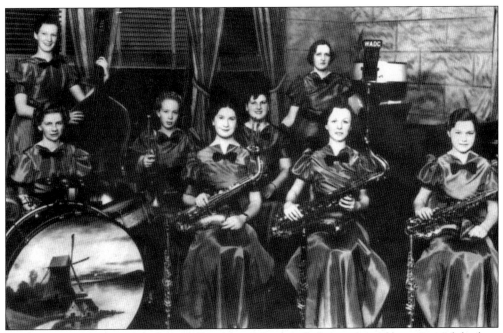

Back in the 1930s and the 1940s, "all-girl bands" were all the rage in Akron. One of the best was the Co-Eds, led by Eleanor Krannick (pictured at the drums). The group, which originally included only Krannick and her cousins, eventually drew some of the best women musicians in the city. Here, the Co-Eds are pictured ready for a broadcast on radio station WADC of Akron in the early 1940s. The group also played on the radio station KDKA of Pittsburgh. (Photograph courtesy Marjorie H. Schmidt, pictured on the right with her saxophone.)

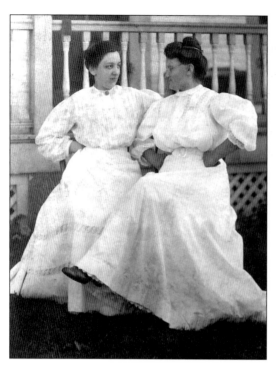

Even in the early 1900s, women liked to kick up their heels and have fun, as shown in this photograph of Margaret Niess Aberth and her friend Lizzie Haas in front of the Haas farmhouse. Margaret's husband, Henry, lived with the Haas family after he came to this country from Germany at age 14. Together, Henry and Margaret founded the City Baking Company in Akron in 1910. (Photograph courtesy Nancy Baumgardner, Margaret's granddaughter.)

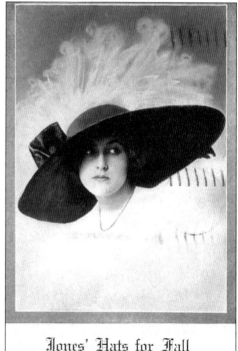

When this advertising postcard was sent out to Akron customers in 1919, every woman seemed to wear a hat. Although women ran many Akron millineries, this one was owned by John A. Jones. His store was on South Howard Street, and he and his wife, Frances, lived on Oakdale Avenue. (Postcard courtesy Kathleen L. Endres.)

Jones' Hats for Fall
on Show Saturday, September 9th
Jones' Millinery
Akron's Best 37 South Howard Street

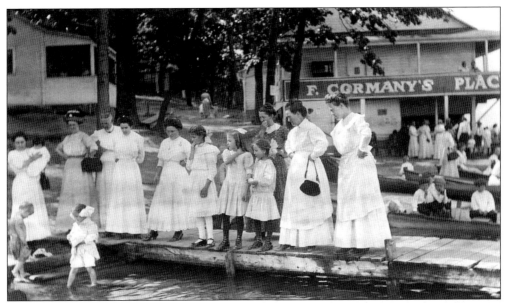

Women have had the primary child-care responsibilities throughout Akron's history. Here, many women keep an eye on two children wading at Cormany's Landing. The photograph was taken in the early 20th century. (Photograph courtesy Summit County Historical Society Collection.)

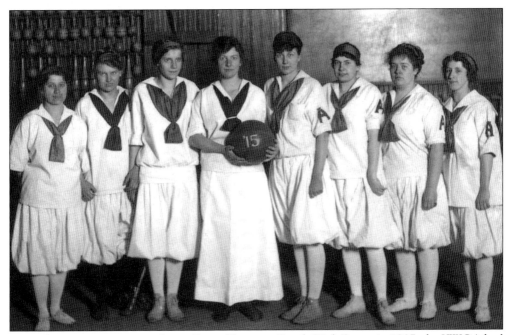

Once the organization moved into Grace House on South High Street in 1907, the YWCA had some of the best "physical culture" and gymnastics facilities for women in the city. The organization formed many athletic teams, including this basketball team in 1915. (Photograph courtesy YWCA of Summit County Collection.)

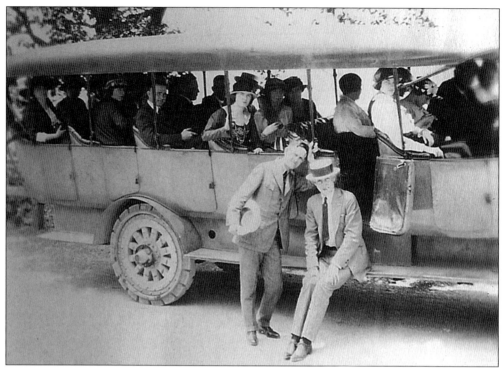

A group of women, including the Casey family from Goodyear Heights, head out for a day trip. The photograph did not indicate where they were headed that day in the 1920s. (Photograph courtesy Kathleen L. Endres.)

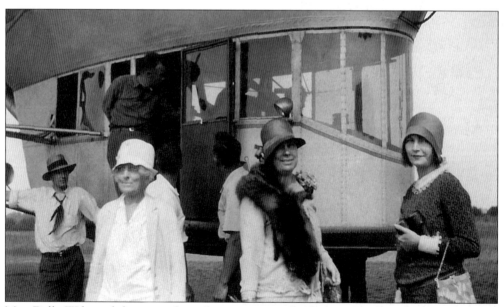

Mrs. Della Wilcox, left, poses after taking a trip on the famous Goodyear blimp in the late 1920s. A flying enthusiast, Della joined the National Aeronautic Association of the United States in 1931. For a time, Akron women formed one of the group's largest contingents. (Photograph courtesy Kathleen L. Endres.)

The women of Ohio Bell Telephone's Accounting Department enjoy a day out at Chippewa Lake, June 19, 1926. Chippewa Lake was a popular destination for the adventuresome from Akron. Located in Medina County, the summer resort featured swimming (on the state's largest spring-fed lake), a boardwalk, amusement park, ballroom, and hotel. (Photograph courtesy Bev Coss Collection.)

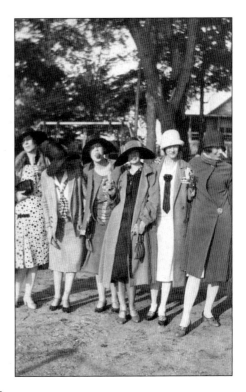

Irma Christopher settled in Akron with her sister Vida in 1920. Both got jobs at Goodyear Tire and Rubber Company. Although they worked hard at the plant during the week, they had time to enjoy the city on the weekend. Here, Irma poses near one of the roller coasters at Summit Beach Park, a now closed amusement park in Akron. (Photograph courtesy Mary Boley, Irma's niece.)

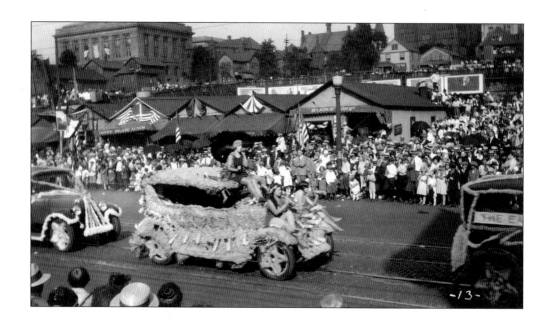

Summers are never long enough in Akron. Many Akron women use any excuse to don a swimsuit and have some fun. In 1925, a group of fun-filled women (top) used the city's centennial anniversary as the excuse to show off their swimsuits. The whole Casey family of Goodyear Heights (bottom) gets into the act one hot sultry day in the 1920s. (Top photograph courtesy Akron-Summit County Public Library, Special Collections; bottom photograph courtesy Kathleen L. Endres.)

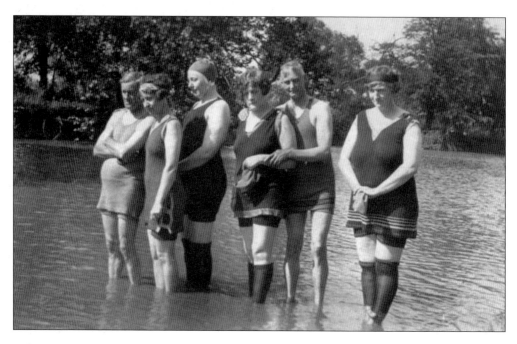

Evelyn Hill was an entertainment dynamo in Akron in the 1920s. She was not only a dancer but also a skilled musician. Evelyn (left) performed with Jean Reed as part of Clemente Brown's Specialty Act at the Goodyear Theatre in the 1926–27 season. The two also appeared at the Colonial Theatre in the "Stepping Out" New York Company. Evelyn was also the leader of the "Ritzi Revelers." Organized originally as the city's first all-girls' dance orchestra, Evelyn dissolved that group when she found it difficult to keep the young female musicians focused. The group was re-instituted soon after under the same name but with male musicians—and Evelyn on the saxophone. The Ritzi Revelers (pictured below) included Virgil Price, Sammy Smole, Bob Guinther, Hadsell Baum, Robert Raynor, Eddy Karl, and Evelyn and perform here on the third floor of Goodyear Hall. At the time, Evelyn attended the University of Akron. Evelyn graduated from East High School, performed instructional dance at East Market Gardens Ballroom, and went on to work at Goodyear Tire and Rubber Company. (Photographs courtesy Donna Vinciguerra.)

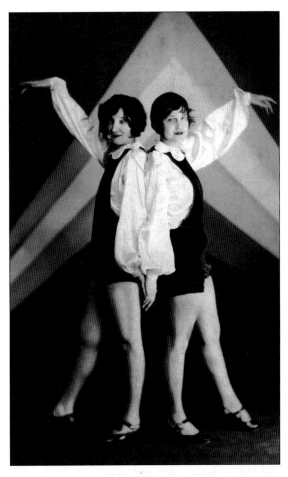

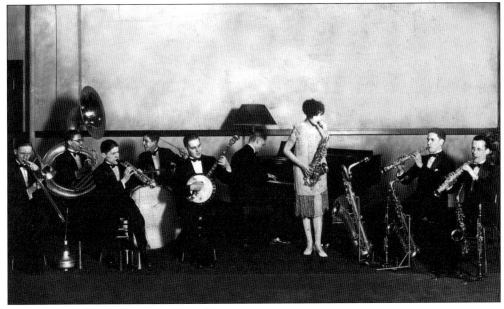

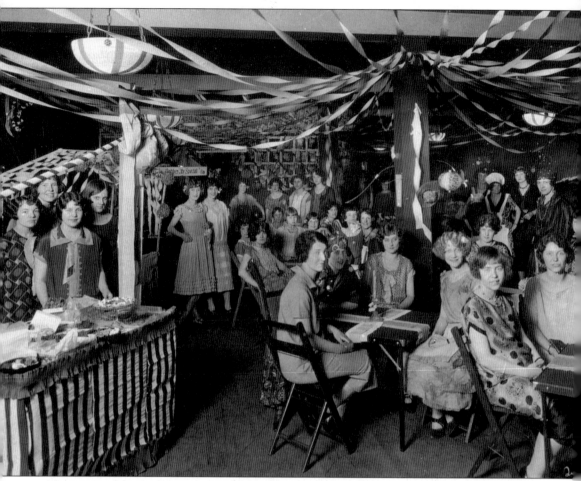

Meet some of the working women of Akron during the 1930s. They are enjoying just one of the many dances and socials sponsored by the Industrial Department of the YWCA. The group was designed to help working women "find an abundant life and to cope with the practical problems of today." Social events, like this one, were held at Grace House in the early 1930s. (Photograph courtesy YWCA of Summit County Collection.)

Meet one of the performers in the Billy Sells Circus of 1938. The circus, which performed under the big top, was a popular attraction in Akron during the Depression. Coming to town also meant that Elizabeth Grudier Sells (Billy Sells' wife) could visit her niece Esther Geiger. (Photograph courtesy Special Collections.)

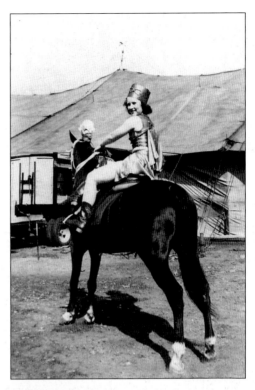

There were many places to enjoy a night out in downtown Akron during the 1940s, and none was finer than the Continental Grove on South Main Street. This upstairs nightclub had a revolving bar and drew top orchestras and big bands for its floorshows. Fan dancers were a regular feature. Here, the club's roving photographer snaps five unidentified Akron women enjoying a night on the town. (Photograph courtesy Kathleen L Endres.)

Mary Alice James sent this photograph to her husband Luther to remind him why he was fighting during World War II. Like so many others in Akron, Mary Alice and Luther were transplants from the South. Both were from Hickory, Mississippi. Luther moved to Akron in the 1920s in the hopes of finding a job in one of the rubber factories—he found his at American Hard Rubber. Mary Alice came up in the 1930s and worked as a waitress and beautician. The two met in Akron and married in 1941. (Photograph courtesy Judy James, who married the son of Mary Alice and Luther.)

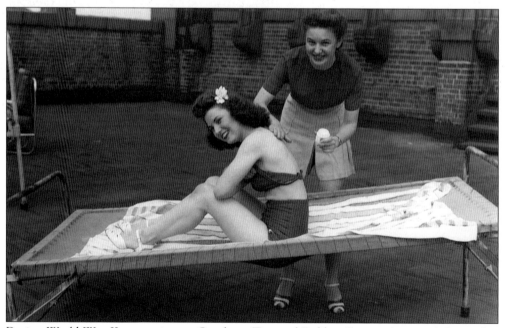

During World War II, executives at Goodyear Tire and Rubber Company opened the roof to war workers for a little sunbathing at lunch time. Women and men were not allowed to sunbathe together, so two days a week, men had access to the roof, and on alternative days, women did. (Photograph courtesy Goodyear Tire and Rubber Collection.)

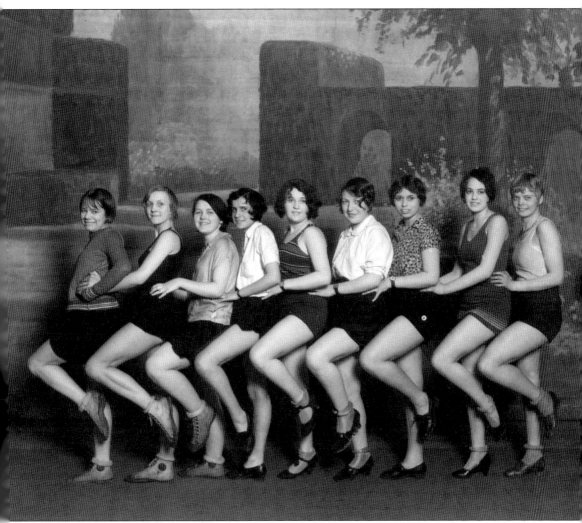

Rubber factory women showed off their musical talents in many ways. Here, the Engineering (?) Pleasure Company performs *Parr*, a musical comedy, at the Goodyear Theatre in February 1930. The dancers are identified as Vera McClure, Dorothy Carlson, Catherine Galleher, Enid Cottrell, Catherine Fleming, Ellen Donovan, Dessie Spangler, Pauline Code, and Helen Tennissen. (Photograph courtesy the Goodyear Tire and Rubber Company Collection.)

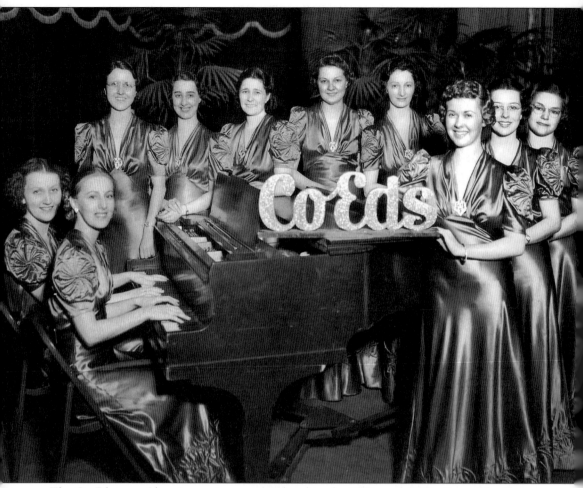

The Co-Eds were Akron's premier women's band in the 1930s and 1940s. Started by Eleanor Krannick, the drummer/singer of the band, the group played most of the city's hot spots, including Summit Beach and East Market Gardens. Among the Co-Eds in the 1940s was Marjorie H. Schmidt, pictured at far right. She passed on her musical talents to her daughter Sue (see p. 119). (Photograph courtesy Marjorie H. Schmidt.)

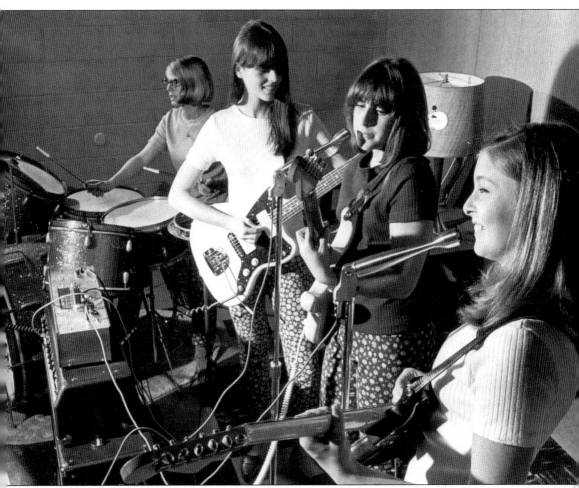

In the 1960s, Akron was a center for rock music innovation. Such groups as Devo and the Rubber City Rebels came out of that fertile environment. So, too, did the Poor Girls. This photograph, taken in 1965, shows four Litchfield Junior High students (from left): Esta Kerr (on drums), Pam Johnson, Debbie Smith, and Sue Schmidt, daughter of Marjorie Schmidt of the Co-Eds (see p. 118). The group stayed together throughout their years at Firestone High School. Sue and Debbie later went on to play with Chi-Pig. Today, Sue teaches history at the Cleveland Institute of Art and at Case Western Reserve University, and Debbie is an attorney in Akron. (Photograph courtesy Susan Schmidt Horning, reprinted with permission from the *Beacon Journal*.)

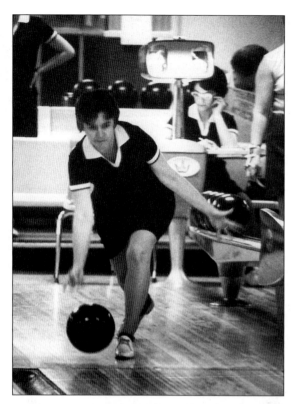

Lucrete Endres has been bowling in Akron regularly for almost 60 years. When this photograph was taken in 1971, she bowled in a league at Roll-A-Way Lanes. Today, at 85 years old, Lucrete still bowls. (Photograph courtesy Fred Endres, Lucrete's son, who also bowls.)

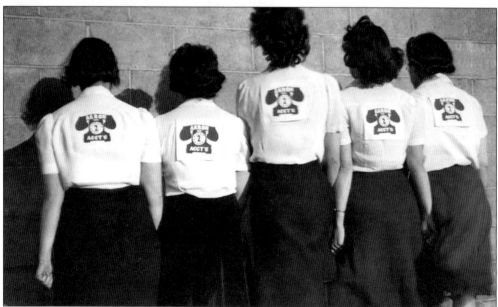

In the 1940s and 1950s, every self-respecting bowling team had to have personalized shirts. In 1942, the women of the Ohio Bell Accounting Team showed off their creativity with their bowling shirts. Team members are (from left) Marguerite Evans, Marion White, Helen Brown, Ruth Dantzler, and Helen Curtis. There's no record of how well the five did. (Photograph courtesy Bev Coss Collection.)

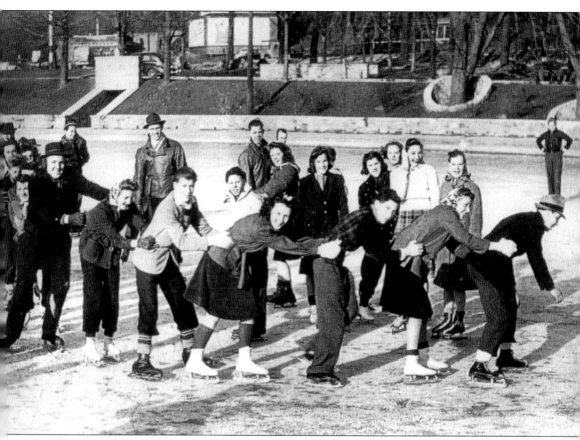

In Akron, winters are long and bitter, but there is one benefit to this weather. There is nothing better than heading down to a rink, pond, or frozen parking lot for some ice-skating. This photograph from the 1950s shows just how much Akronites—youngsters and adults—loved their ice-skating. (Photograph courtesy Kathleen L. Endres.)

Famous golfer Babe Didrikson Zaharius inspired an entire generation of women to give the golf game a try. One of the Akron women who enjoyed a good round of golf was Dorothy Heiner, an accountant at Richmond Brothers downtown. Here, she poses with clubs and golf trophy in the early 1950s. (Photograph courtesy Pamela Parks Costa, Dorothy's goddaughter.)

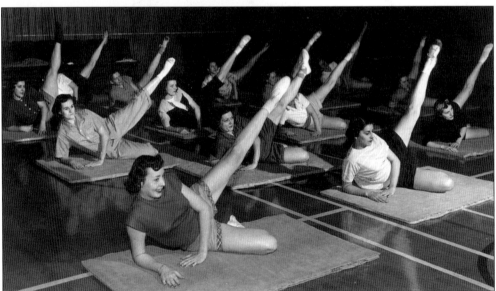

One of the best places for Akron women to get a good workout in the 1950s and 1960s was the YWCA. In this undated photograph from the 1960s, women get in shape at the YWCA's headquarters on South High Street. (Photograph courtesy YWCA of Summit County Collection.)

In the 1940s, the dance craze was the jitterbug, and this unidentified couple shows how it is done at one of the many YWCA dances in Akron. (Photograph courtesy YWCA of Summit County Collection.)

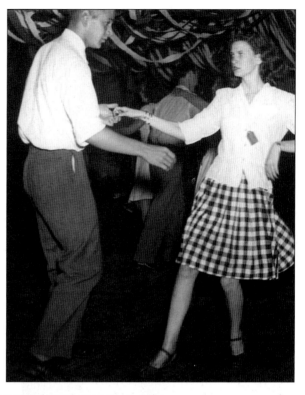

Ohio Bell Telephone Company employees enjoy a cookout at the company bowling league's "wiener roast" at Perkins Park on June 15, 1943. They are (from left) Gertrude Evans, Mary Ostair, Anne Clayton, and Nina Wohlford. (Photograph courtesy Bev Coss Photograph Collection.)

Lucrete Endres was out for a shopping trip in East Akron with her daughter, Faye, when she spotted this photo opportunity. The photographer/dog trainer supplied the pooch props, and Lucrete supplied the smile. (Photograph courtesy Lucrete Endres.)

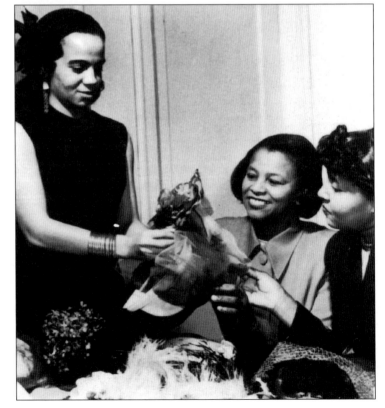

Akron women have always shown a creative side. Here, three women in the 1960s learn how to make hats at the YWCA headquarters on South High Street. (Photograph courtesy YWCA of Summit County Collection.)

During the late 20th century, many Akron women took self-defense classes. Here, an instructor at the YWCA demonstrates one maneuver women can take to protect themselves. (Photograph courtesy YWCA of Summit County Collection.)

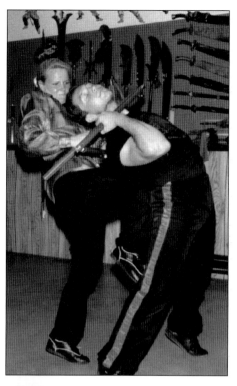

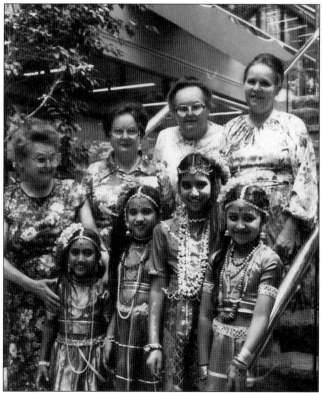

Akron immigrants come from all parts of the world. In this photograph taken at the 1985 Naturalization Ceremony, the four Toth sisters from India pose in front of four women from Hungary. The Toth sisters were dancers from the India Community Association of Greater Akron. (Photograph courtesy International Institute.)

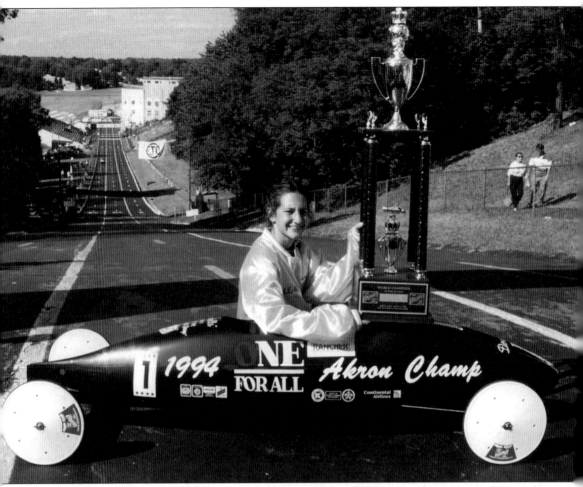

In the 1994 Soap Box Derby, Danielle DelFerraro, representing Akron, made history by speeding to the finish line in the Master's Championship Race. She is the only two-time world champion in the history of the Soap Box Derby. (Photograph courtesy Soap Box Derby.)

Basketball star Pam Arnold, playing for the University of Akron Zips, shoots from outside. Arnold was the first University of Akron player to earn All-American honors and set the school's record for career rebounds. She played for Akron from 1985 to 1988. (Photograph courtesy the University of Akron Sports Information.)

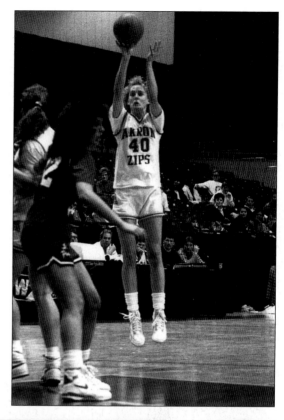

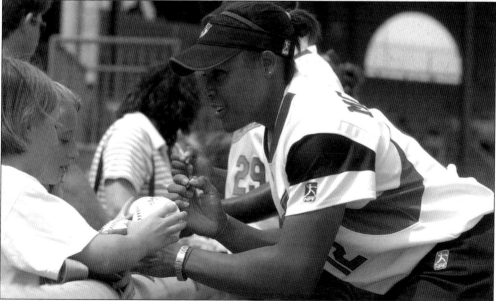

In 1999, Akron became one of six cities in the nation to have a women's professional fastpitch softball team. Akron Racer outfielder Iyhia McMichael signs a souvenir ball for a young player in 2004. She was also the National Pro Fastpitch League's Most Valuable Player the same year. (Photograph courtesy Akron Racers Foundation and Jeff Harwell.)

BIBLIOGRAPHY

Photographic Collections:
Archives, Children's Hospital Medical Center of Akron.
Archives, International Institute, Akron.
Archives, Sisters of Charity of St. Augustine, Richfield, Ohio.
Archives, Sisters of St. Dominic of Akron.
Archives, St. Bernard's Catholic Church, Akron.
Archives, Soap Box Derby, Akron.
Archives, United Disability Services of Akron.
Archives, Western Reserve Girl Scout Council, Akron.
Archives, Zion Lutheran Church, Akron.
B.F. Goodrich Collection, the University of Akron Archives, Akron.
Bev Coss Collection, Special Collections, Akron-Summit County Public Library.
International Institute Collection, the University of Akron Archives.
Sam Shepard Collection, the University of Akron Archives.
Special Collections, Akron-Summit Public Library.
Summit County Historical Society Collection, the University of Akron Archives.
Young Women's Christian Association of Summit County Collection, the University of Akron Archives.

Books:
Endres, Kathleen L. *Rosie the Rubber Worker: Women Workers in Akron's Rubber Factories During World War II.* Kent, Ohio: Kent State University Press, 2000.

Grismer, Karl H. *Akron and Summit County.* Akron, Ohio: Summit County Historical Society, 1952.

Kenfield, Scott Dix (ed.). *Akron and Summit County Ohio 1825–1928.* Chicago and Akron: S.J. Clarke, 1928.

Knepper, George W. *Akron: City at the Summit.* Tulsa, Oklahoma: Continental Heritage Press, 1994.

Lane, Samuel A. *Fifty Years and Over of Akron and Summit County.* Akron: Beacon Job Department, 1892.

Nichols, Kenneth. *Yesterday's Akron: The First 150 Years.* Miami, Florida: E.A. Seemann Publishing, Inc., 1975.

Zonsius, Patricia M. *Children's Century: Children's Hospital Medical Center, 1890–1990.* Akron: Children's Hospital Medical Center of Akron, 1990.